Dragon Draw

Learn to Paint, Draw and Design Dragons

Piper Thibodeau

IMPACT

Contents

Introduction

Dragon Draw is an art book about drawing fantastical and comical dragons. You will learn everything from drawing basics to character design to painting so that you can incorporate these lessons into your own work and create some great dragons. To give you plenty of examples, I've tried to vary the look of the dragons. You'll find zany dragons, like those you'd see in animation, as well as the more traditional sort that dominate card and roleplaying games.

Though the majority of this book contains digitally drawn creatures, it can also be followed by anyone who has access to a pencil. To level the playing field for readers who may not be accustomed to drawing digitally, or who may prefer to make a hybrid of digital and traditional mediums, we will cover a few traditional tools that can be used while following the book's tutorials.

This book is aimed at those who are either dragon hobbyists for the fun of it or who want to acquire new skills to improve their artwork. However, if your aim is to become a professional artist, this book alone won't cover the entire gamut of the many different art fields; rather, it will hopefully point you in the right direction. Character designing, illustration and other art fields all span a lot of material. I have attempted to cover subjects that are universal in all of these disciplines. Now let's Dragon Draw!

Traditional Tools

While we will discuss digital tools and techniques, you can absolutely use this book to enhance your dragon-drawing skills even if you have no interest in the computer medium at all. And if you're new to digital art, you will discover insight on how to bridge the gap between traditional and digital art.

Glossary

- **CMYK:** Color model in printing using the basic colors cyan, magenta, yellow and black.
- **Copyright:** The exclusive content of a creator.
- **DPI:** Dots per inch, the resolution of the image on screen.
- **Digital art:** Art created using digital tools, such as Adobe Photoshop.
- **Digital print:** A printed copy of a digital art piece.
- **Fair use:** Copyrighted content that may be used by others, often conditionally.
- **RGB:** Color model on screens using the basic colors red, green and blue.
- **Scan:** Scanning a physical image and creating a digital replica.
- **Software:** Computer programs.
- **Traditional art:** Art created using traditional tools, such as pencils and paint.
- **UI/user interface:** Visual interface with which a computer user interacts.

Traditional Tools List

Here are some of the traditional art tools you can use. The brands listed in parenthesis are a good place to start, but there are many great products out there in various price ranges. Choose what works best for you.

- Sketchbook (Canson, Pentalic Traveler, Moleskine)
- Wooden graphite pencils (Staedtler, Derwent, Uni Mitsubishi)
- Erasable red and blue pencils (Col-Erase, Staedtler, Ticonderoga)
- Fine liner pens (Pigma Micron, Copic Multiliner)
- Alcohol markers (Copic, Prismacolor, Blick Studio)
- Watercolor pencils (Derwent, Faber-Castell Albrecht Dürer, Arteza)
- Watercolor set (Winsor & Newton, Daniel Smith, Sakura Koi)
- Watercolor paper (Arches, Canson, Strathmore)
- Fine-tip brush set (Heartybay, Xubox, Virtuoso)
- Basics: erasers, ruler, pencil sharpeners, glasses to hold water and your brushes

The Tool Does NOT Make the Artist

Expensive art materials are not necessary right away and they will not miraculously improve your work. In fact, they could harm your progress. Purchasing expensive materials can make you reluctant to make helpful mistakes in order to preserve your investment. If you're new to something, it's better to anticipate and even encourage yourself to make as many mistakes as possible. The tool does *not* make the artist. Skilled artists can make a masterpiece using crayons if they please. Higher grade art materials equate to more variety, colors and ease of use, but you might not even notice the difference when you are just starting off.

Digital Tools

Digital tools are a bit more expensive than traditional tools, and therefore an investment, but you only need a few of them. I've listed a few brands and specifications as a starting point, but there are many others. Do some research and find something that works within your budget.

Digital Programs

In this book, I'll be using Adobe Photoshop® Creative Cloud for the demonstrations. Bear in mind that Adobe products, like Photoshop, are on the higher end of painting programs and can cost quite a lot. Check out some less costly alternative programs before committing to an expensive one. They all have interfaces similar to Photoshop, and you should be able to follow along with the book's digital assignments without any issues.

Drawing Tablets

Wacom products are popular drawing devices, but much like Adobe, they can be quite pricey. Thankfully, there are alternatives available on the market. There are two varieties: those that allow you to draw directly onto the screen like you would a sketchbook, and those that function like a computer mouse but with a pen and pad. The latter is more affordable and I recommend that if you're just getting started.

Digital Tool List

- Digital painting software (Adobe Photoshop, Corel Painter, Paint Tool SAI, Procreate)
- Drawing tablet (Wacom, Huion, Apple iPad)
- Scanner (Canon, Epson)
- Computer: One that meets the requirements of digital programs. Typically 2 GB of RAM and decently fast processor. Please check the specific system requirements for your drawing software of choice.
- Computer Screen: A monitor that is at-least 24" wide or larger with a wide color gamut. Brands like Dell and EIZO are good fits.
- Camera: A DSLR camera will generate print-quality photographs of your artwork. A compact camera or even an iPhone camera can capture a decent image quality.

Digital Program Options

There are many digital software options:

- Adobe Photoshop CC
- Procreate
- Paint Tool SAI
- GIMP
- Krita

Drawing Tablet Options

These are just a few of the drawing tablet options:

- Wacom (Bamboo, Intuos, Cintiq)
- Huion (H610 Pro, Kamvas GT-191)
- XP-Pen Artist 16
- iPad with Pen
- Surface Pro with Surface Pen

Digital Drawing 101

Drawing software can be bone-chillingly intimidating at first. In spite of its labyrinthine appearance, you'll quickly learn to conquer the digital beast.

Get to Know Your Program

The programs I mentioned provide preferences, hot keys and brushes that you can customize. Whatever you choose to use, get as comfortable with it as possible. The more functions and shortcuts you grasp, the more effectively you can use the program. Also, software creators often share a vast array of tutorials on their websites. Please take advantage of these. We will cover some of the most basic and frequently used preferences here.

Accessing the Keyboard Shortcuts Menu

The location of the keyboard shortcuts menu depends on your software. When in doubt, search through your respective program's set-up guides, or search YouTube for the "101 Introduction" to the basic functions of your programs. Photoshop users, access the keyboard shortcuts menu by going to the top bar, clicking Edit and scrolling down to Keyboard Shortcuts.

Accessing Your Tablet's Shortcuts Menu

Some drawing tablets (and pens) are equipped with buttons that can assign hot keys. Should you prefer, you can use these buttons instead of the keyboard. Consult your tablet's user manual to find where the hot key modifiers are for your device.

Starting a File

There are three important things to keep in mind when starting a file:

- Decide the dimensions of your drawing based on the image you're planning to create. If you're not sure what size to start off with, try 1000 × 1500 pixels as a minimum. You can always alter the size later.
- If you intend to print your piece, set the resolution to 300 dpi. Web-only images are usually 72 dpi.
- Color modes are also related to the image's final purpose. If you're working on something that you wish to print, use CMYK to retain the correct colors. If your image is for web use, create it in RGB. You can switch between modes if necessary, but be aware that your colors might be affected.

Using Brushes

All programs have their own default brushes. Depending on the software, you can usually import or create your own brushes. To import new brushes in Photoshop, go to the Preset Manager on the brushes toolbar and select Load Brushes from the dropdown menu.

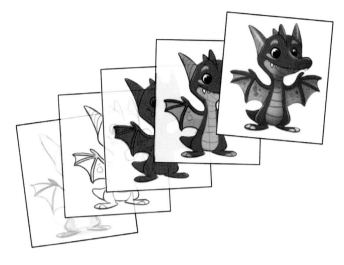

Setting Hot Keys

With hot keys—or keyboard shortcuts—you can program your keyboard or tablet to follow through with a software function. For instance, hitting "E" on your keyboard will automatically select the eraser; you won't have to click on the eraser icon in the toolbar. By default, your drawing software will pre-assign hot keys for software functions. These can easily be altered by accessing the Keyboard Shortcuts menu.

What Are Layers?

Using layers in digital programs is akin to taking a fresh piece of tracing paper, putting it over an existing sketch and drawing on top of it. The sketch below is still present and visible, but you're not drawing on it directly, and the original sketch is maintained.

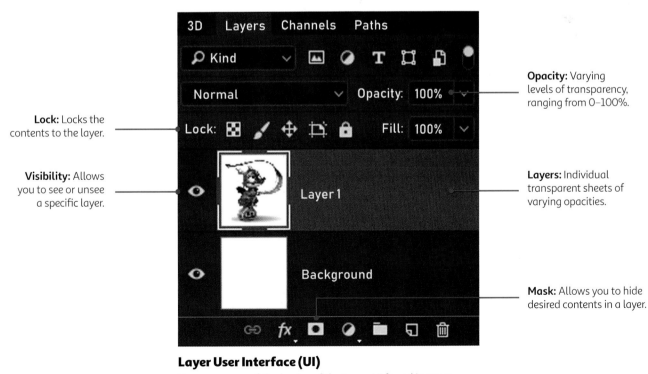

Lock: Locks the contents to the layer.

Visibility: Allows you to see or unsee a specific layer.

Opacity: Varying levels of transparency, ranging from 0–100%.

Layers: Individual transparent sheets of varying opacities.

Mask: Allows you to hide desired contents in a layer.

Layer User Interface (UI)

Here are some of the basics of the Layer UI found in most digital programs.

1 Drawing Basics for Dragons

Art foundations are like the structural beams that hold up a house. Without the beams, the house can't stand up. They may not be the most exciting part of drawing, but without the structure, your dragon drawings won't stand up and will look wonky. In this section, you will learn about shapes, lines, volume and perspective. With these skills in your artistic toolbox, you will spend less time scratching your head over fundamentals and more time drawing dragons.

Be wary of skipping ahead into the coloring, texturing and detailing segments of this book, especially if you're a beginner artist. The exercises may not feel the most exciting, but no amount of coloring or detail can hide basic mistakes.

Through learning about shapes, you will understand how to develop **shape vision**, seeing drawings as a breakdown of different shapes rather than as a confusing hodgepodge of details. Through grasping volume and lines, you can turn those shapes into three-dimensional drawings that will give your dragons a more realistic appearance. And through learning about perspective, you will understand how to properly integrate your dragons into an environment, and finally, how to create the surrounding environment itself.

Shapes, Artists' Building Blocks

Understanding how shapes work is a very important step to drawing dragons. Dragons are made of shapes, after all!

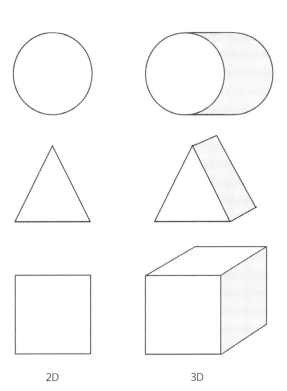
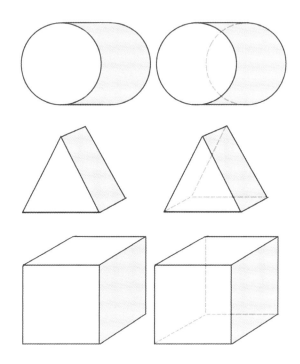

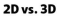
2D 3D

2D vs. 3D
Two-dimensional (2D) shapes are shapes that exist within two dimensions. They are completely flat and are solely defined by their length and height. There are many forms of art that use 2D shapes, such as certain animation styles and sprites for many retro games. Three-dimensional (3D) shapes have the addition of width. They are widely used in art, animation and modern video games.

Draw Through Shapes
Drawing the interiors of basic shapes is a necessary skill to drawing dragons, as dragons are composed of many different shapes. For practice, draw as many basic 3D shapes on a piece of paper as you can, then figure out what they would look like if they were transparent.

With practice, understanding how these shapes look from the inside will become second nature.

Design a Dragon with Shapes

Once you're comfortable drawing basic shapes, you can move on to using these shapes for your dragons. In this example, you can see how the dragon is composed of cylinders, circles and triangles. Try making your own shape-based dragon. Look at its underlying shapes first and then add the details.

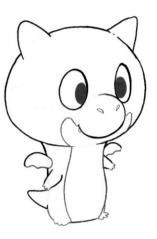

1 Block Out the Basic Shapes

With a blue pencil, block out the basic shapes of the dragon. This example is comprised of spheres (for the head and muzzle), cylinders (for the body) and cones (for the horns, tail and limbs). Keep the shapes transparent.

2 Draw the Basic Form

Using a pen or HB pencil, draw the basic form of the dragon over the transparent shapes. Use the underlying blue lines as a guide, but not as a rule. Don't close the lines around the muzzle, arms or neck. Doing so would make the drawing look too segmented, like a toy.

3 Focus on Smaller Details

With the major form of your dragon drawing complete, it's time to focus on the smaller details. Rather than just a flat cone for wings and limbs, add digits. Add details to the face, like the mouth, eyes and nostrils, always conforming to the blue-lined shapes you established earlier.

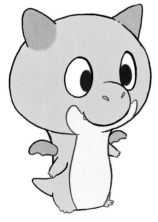

3D Character

Now we are left with a fleshed out 3D character. When we are satisfied with the details, we can add basic colors to cover up the blue lines, which we no longer need.

Shapes for characters are seldom this obvious. As you improve your dragon drawing, you can anticipate much more of a challenge in this regard. Practice drawing shapes as much as you can so you'll be ready.

Ellipses

An ellipse is an oval shape in perspective that varies depending on how the viewer is looking at it. Getting ellipses wrong confuses the viewer because it's not how perspective works in real life. It may seem irrelevant to drawing dragons, but dragons often have ellipses in their scales.

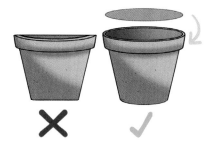

Drawing Ellipses

A good example of ellipses is a flower pot. Depending on the position of the viewer, the hole at the top of the pot looks different. If the view is of someone lying on her belly, she couldn't see the top of the flower pot. But if she were standing at a short distance from it, the top would appear rounded.

> ## Exercise 1:
> ## Design Dragon Horns
>
> Create three simple dragon heads with plain horns. With a colored pencil or digital brush, sketch where the ellipses would fit for each. Be sure to draw through the image to get your ellipses correct.

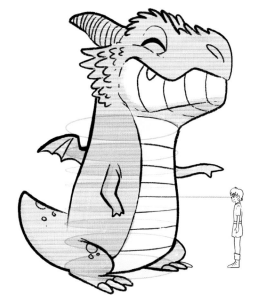

Ellipses Vary Depending on Eyeline

Imagine you're the human in this example. The appearance of the dragon's belly ellipses will vary depending on the horizon line, which means the eye level of the viewer. The eye level, and therefore the angle of viewing, would change if the human were taller or shorter.

Creating Ellipses on the Dragon

We will now apply ellipses to the body of a long robotic dragon. We will determine how to draw ellipses with a challenging perspective—with the dragon's head being the closest to our eye level while the tail extends far from view.

1 Start with a Shape
Create the long, cylinder-like shape that will be our dragon. Since the end of the tail is far off in the background, make sure to give it the impression of distance. Think of it like a tree. A tree in the distance looks small, but it may be just as large as the tree beside you. The dragon's tail isn't really that small, but it looks this way because of how far away it is.

2 Find Direction
It's important to consider where the eyeline is in this piece. It looks as though we're marginally above the dragon, so the ellipses should look like they're below us and not above.

Also, the dragon's body is not a straight tube, so be careful about the changing directions of the belly scales.

3 Fill in the Rest
Now that you have a better idea of the direction of the ellipses, you can comfortably add the in-between scales. They should bunch up more as they reach the farthest point.

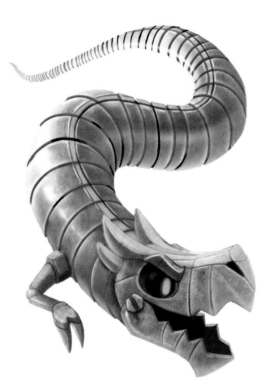

4 Fix Inconsistencies and Add Final Touches
You might notice little inconsistencies in your ellipses that you can tweak. You might need to go back in and create some space in between your ellipses, or fix up the curves.

Line

Having a variety of line skills in your art-skill arsenal comes in handy in many different respects. Although some pieces of artwork might have lines the same weight intentionally, many art pieces can be enhanced with varying weights, as they help indicate distance and volume. There are also common shading techniques using repetitive line patterns that can quickly turn a plain doodle into something with depth. By learning these skills, you will hopefully avoid the habit of erasing lines and redrawing, and instead, have more time to concentrate on your dragon designs.

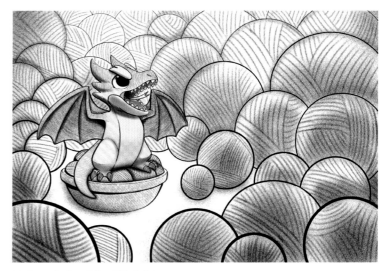

Line Weight and Light

Light and shadow can also affect line weight. The closer the lines are to the light, the thinner they should be. Conversely, lines in the shadows are thicker.

Determining Line Weight

Like the example for the ellipses earlier, line weights will vary depending on how close or how far they are from the viewer. If the lines are farther in the distance, they're best represented with thinner lines. If they're close up, they would have bolder lines. This gives the illustration a sense of depth, even if the work is two-dimensional.

Practice Making Lines

If you're struggling to get the hang of line control, thankfully there are exercises you can do to master it. All you need is a pen or a marker. The only rule is not to let the pen leave the paper. This is called the line-wave technique.

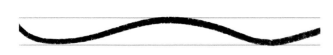

1 Repeat the Pattern
Think of these lines as though they were ocean waves. Start off with a simple, repetitive wave bump. Repeat this pattern for the entire length of the paper.

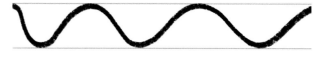

2 Be Consistent
Now the winds are starting to pick up. For the second line, draw higher and shorter bumps while trying to keep the pattern consistent. Don't sweat any mistakes; just keep going.

3 Maintain Control
For our third line, we have a strong tide building up. This is like a double curve: you're controlling the curve going up the tide and the curve building from underneath it. Try to keep them all at a similar level.

4 Focus on Details
Tsunami! Focus on maintaining the consistency of the swirls. Once you've swirled to the center of the wave, you'll need to repeat the path you took and push out from below into the next swirl. Rinse and repeat.

Shading Methods Using Line

Learning to use different shading techniques can be useful for approaching various types of subjects or materials in your dragon drawing. Though these techniques are commonly used to give a drawing realism, nothing here is set in stone. These shading techniques can also be used in a stylistic manner.

Exercise 2:
Create and Shade Scales

Draw four simple rows of dragon scales. Practice shading the scales using one of the shading methods covered in the chapter. An HB pencil is recommended for this exercise.

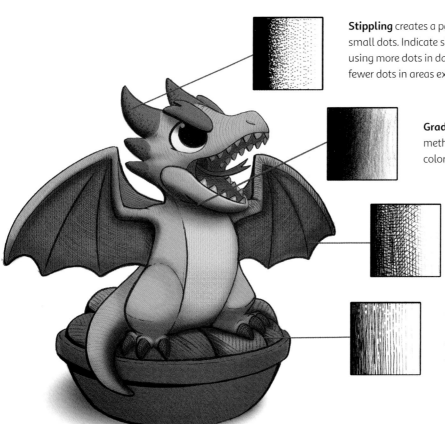

Stippling creates a pattern using many small dots. Indicate shade or volume by using more dots in darkened areas and fewer dots in areas exposed to light.

Gradient is the most basic shading method of filling an area with a darker color that gradually lightens.

Crosshatching is similar to linear hatching, but the lines intersect from different directions rather than running parallel.

Linear hatching uses straight lines to indicate shading. Lines that are close together or overlapping indicate dark areas while spaced-out lines indicate light areas.

Traditional Inking Steps

When starting your underdrawing with a colored pencil, keep your lines light and erasable. This way you can easily rectify any mistakes at this early stage. Creating an underdrawing allows you to explore features on your drawing without committing it to the final artwork. If a detail feels off, deal with it before drawing over and finalizing it with lines from a darker pencil or a pen.

Crosshatching Tip

You can layer your crosshatching to get darker effects and add shading.

1 Rough Sketch
Use a light pencil (color or plain) to draw a basic dragon head shape.

2 Fine Pen
Draw over your pencil lines with a fine liner pen. This step is optional. If you have good control of your lines, feel free to skip to step 3.

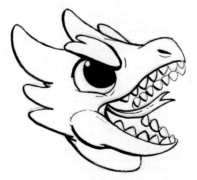

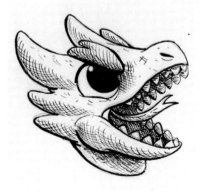

3 Brush Pen
Using a brush pen, add line depth to your dragon's lines. Consider where the light is hitting your dragon and which spots will be the darkest (here it's the underneath of the jaw and brows).

4 Detail Lines
Using your fine liner pen again, detail your sketch with some crosshatching. Note the darker shading in the area under the jaw.

Digital Inking Steps

Many artists who get crisp, clean lines will start off by loosely sketching the drawing with a marker, pen or a digital brush. This process is called inking. The amount of detail in this sketch will vary from artist to artist. Though this is a preference, I find that using a red pencil helps differentiate the sketch from the inking.

Digital Inking with Layers

In your chosen software, create a new layer above the background layer. Name it SKETCH LAYER.

1. Draw your initial sketch. When finished, lower the opacity to approximately 30–60%.
2. Create a new layer above SKETCH LAYER. Name it LINE LAYER.
3. Trace over your initial sketch with refined, clean lines.
4. Delete SKETCH LAYER.

Volume

Volume is the amount of space an object consists of, like the space inside a circle. Understanding the volume of a 3D form will allow you to create convincing forms. Later, when you delve into painting, these volumes will play an important part in the painting process because understanding the volume of the underlying shapes allows you to produce a better painting. This will affect the application of light, shadows, textures and small details to your dragons.

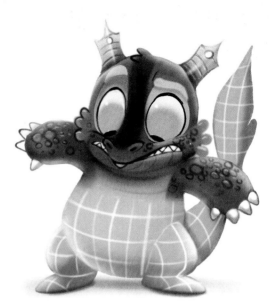

Volume and Shading with Graph Lines

Understanding volume is also key to understanding how to apply shading. Three-dimensional forms are not flat surfaces, and shading needs to conform to the subject's shape. In this example, the volume moves inward to form a knee, creating space below the knee to add shading. If this is too confusing, think of how these lines would look if applied to an apple: the graph lines would hug the shape, expanding most at the apple's middle circumference and tapering off on the bottom and top. If we were to add shading to that apple from up above, the bottom of the apple would get the least amount of light.

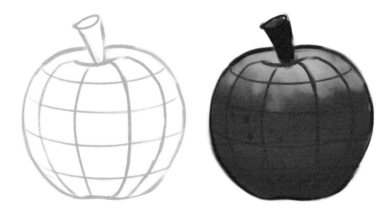

Break Down a Dragon Tail

Break down the basic shape of a dragon's tail into a rough 3D volume.

1 Start Simple
Start off with a simple two-dimensional tail shape.

2 Add Volume
To add volume to the drawing, draw in ellipses or graph lines to show the interior form of the tail.

3 Add Details
Apply smaller details, such as the tail patterns. Now that you have a better understanding of the surface, you can see that the stripes will curve around the top of the tail. With practice, you can learn to do this by eye rather than breaking down every shape. But if you're running into trouble with a shape in your artwork, this is a useful method of simplifying the problem.

Break Down a Head

A character's head is one of the most important shapes in your dragon artwork. Humans are drawn to faces, and we'll normally notice facial errors far more quickly than other mistakes. Having an eye out of place can take away a lot from a piece. To prevent this, practice breaking down a face.

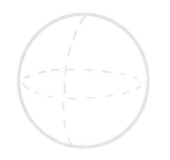

1 Start Simple
Start with a simple two-dimensional circle and quarter it with dotted lines.

2 Make It Three-Dimensional
Now turn the two-dimensional circle into a three-dimensional circle by curving the dotted lines around the volume of the circle. It is now a sphere.

3 Add Volumes
Using the same process as steps 1 and 2, add a muzzle, a neck and eyes to the existing sphere.

4 Finish the Details
Use a darker pencil to draw the design over the spheres. Add pupils, scales, horns and any other details. You now have a 3D dragon head!

Break Down Simple Objects
You can practice breaking down the forms of simple objects by searching the Internet for photos or looking around your home for objects to sketch.

Volume Painting: Start to Finish

In this demonstration, we will create the volume for a full-bodied dragon. Unlike the dragon demo we used at the beginning of this chapter, where we restrained ourselves to using very basic shapes, such as spheres and cones, we will now create a dragon with more complex shapes. This will result in a more organic and lively looking creature, which is typically what we want for our dragon drawings.

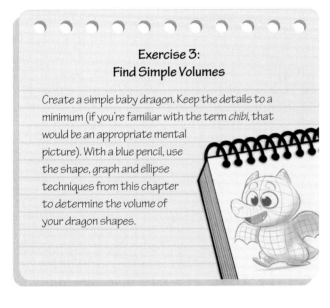

**Exercise 3:
Find Simple Volumes**

Create a simple baby dragon. Keep the details to a minimum (if you're familiar with the term *chibi*, that would be an appropriate mental picture). With a blue pencil, use the shape, graph and ellipse techniques from this chapter to determine the volume of your dragon shapes.

2 Add the Secondary Shapes
Now that you have a foundation, continue by adding the limbs, muzzle, wings, ears and eyes (listed in order of importance). Make the lines for these secondary volumes a tad darker than those you created for the first step. When coloring, you want the shading and lighting to conform to the 3D shapes. The light in this final painting will come from the top-right, so shade and highlight accordingly, with the lightest parts toward the top-right, and the shadows underneath. In later chapters, we will focus on how shading and lighting work in further detail.

1 Draw the Main Shapes
Draw and break down the largest shapes. The body, tail and head are the most voluminous elements, so use ellipses and graph lines to work out the shapes within them. Make these lines as light as you can while still making them comfortably visible. You want to avoid creating visual clutter with the intersecting lines.

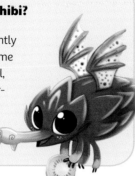
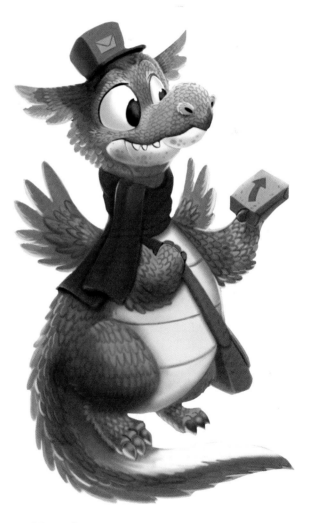

3 Add the Tertiary Shapes

Now add the smaller volumes, such as the hat, scarf, package, bag and claws. It's best to leave these types of items for last because the dragon's body shape will affect their placement. For instance, how the scarf falls or how the hat fits.

4 Add the Final Shapes and Background

For the final stage, add some feathers. Remember to always respect the underlying volume rather than placing them at random. Feathers will also show up better along the figure of the dragon if they're poking out along the extreme edges of the body. You want to make sure the viewer notices them.

Perspective Basics

In order to create three-dimensional representations of your work, you will need to learn to draw in perspective. It may seem daunting at first, but you can do it as long as you practice a few basics.

Eyeline
The *eyeline* refers to the height of the viewer's eyes when looking at a scene. Think of it like a camera that can be moved around in any given environment.

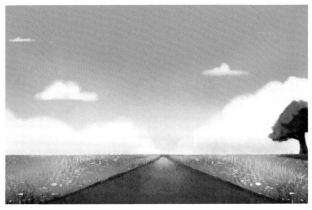

Vanishing Points
Vanishing points refer to points where parallel lines converge. The number of vanishing points determines the type of perspective you're going for.

Bird's-Eye View
A *bird's-eye view* is the perspective of a bird flying over a building.

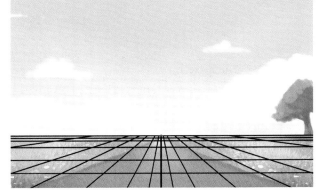

Plane
A *plane* refers to the lined surface across a landscape created using the various perspective techniques (one-point, two-point, three-point, etc.)

Worm's-Eye View
A *worm's-eye view* is the perspective of an insect looking up at a building or other tall object from the ground.

Drawing Basics for Dragons
Drawing in Perspective

Now let's practice drawing in perspective.

One-Point Perspective

One-point perspective is defined as having a single vanishing point toward which all subjects in a painting converge. Imagine you are looking straight ahead while standing in the middle of a long railroad track. The vanishing point where the track edges converge will be a single spot in the far distance. You probably won't use this technique very often for dragon drawings, but you never know when it may come in handy.

1 Draw a Line with a Vanishing Point
Draw a line to indicate the eyeline level. Next, add a single vanishing point anywhere on this line to indicate where the lines of objects will converge.

2 Add Squares
For this example, draw a few squares of different sizes on your plane.

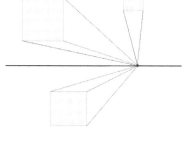

3 Create 3D Squares, Connect Them to the Vanishing Point
Use parallel lines to connect the corners of the squares to the vanishing point. Create 3D squares by drawing straight horizontal and vertical lines that intersect with the converging lines.

Two-Point Perspective

Two-point perspective is very common. It has two vanishing points toward which all subjects converge. This creates more depth and realism. The vanishing points are typically far in the distance and opposite to one another. This kind of perspective is best for scenes at a standing/ground level (neither a worm's-eye view nor a bird's-eye view).

1 Draw the Eyeline and Vanishing Points
Draw the eyeline. Place two vanishing points near the farthest ends of the line.

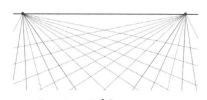

2 Create a Grid
Draw lines radiating from the two vanishing points. The lines should converge to create a grid-like surface. Note that the farther the distance between the two points, the wider the grid will be.

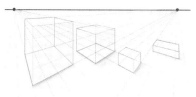

3 Create 3D Shapes
Draw a few different rectangles onto the plane, using the grid to align the sides. Now you can create 3D shapes by connecting the rectangles' corners to the vanishing points. Notice how the rectangles have more depth than those in the one-point perspective example.

27

Three-Point Perspective

Three-point perspective is used to convey the height of a scene. It works similarly to two-point perspective, but with an additional vanishing point either below the eyeline (bird's-eye) or above it (worm's-eye). As a dragon artist, you will often find yourself drawing dragons flying over their environments, so pay particular attention to this technique.

1 Draw the Eyeline and Vanishing Points

Draw the eyeline. Draw two points along the line, but this time add a third point above or below the line, near the top or bottom of your page. Keep in mind the orientation. Top = looking down. Bottom = looking up.

2 Create a Grid

Create a grid using the two vanishing points on the eyeline, just as you did in the previous example. For the third vanishing point, draw lines going upward or downward through the plane, depending on the location of the point. Lines drawn from a point below the eyeline will go upward, and lines drawn from a point above the eyeline will go downward.

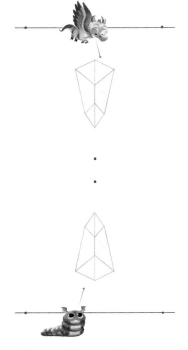

3 Create a Rectangle

Using these lines as guides, create a rectangle. If you created your shape using a bottom point, you will have a bird's-eye view. If you created your shape using a top point, you will have a worm's-eye view.

Isometric Perspective

Isometric drawings are often used in video games to create a 3D overhead perspective while keeping the sprites 2D. This is sometimes due to limited budget or hardware constraints, but it can also be for stylistic purposes or to emulate the feeling of a chess board. As a rule of thumb, there are three different line directions: X, Y and Z. You can buy isometric graph paper, but it's useful to know how to make it yourself.

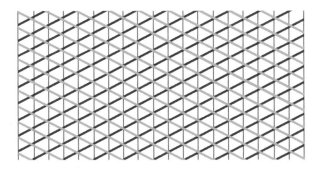

1 Draw the Lines

For the X axis, draw about a dozen vertical lines. For the Z axis, draw an equal number of lines slanted to the right at a 45-degree angle. For the Y axis, create the lines at an opposing 45-degree angle slanted to the left.

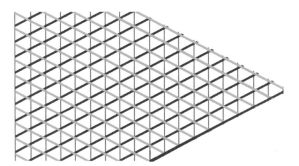

2 Form a Grid

Now you can form an isometric grid out of the axis lines. Use an eraser to create a plane out of the intersecting lines. When you're finished, feel free to erase the Z-axis lines to get a cleaner grid, though this isn't necessary.

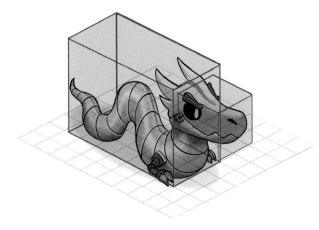

1 Draw a Dragon

Now that you have a grid, you can place a dragon onto it. Draw the dragon within the confines of the isometric perspective grid. To get a better idea of the guidelines, draw a few boxes around the sketch that conform to the grid.

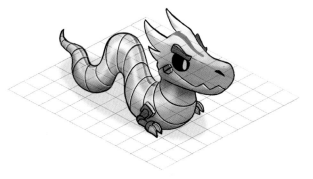

Finished Drawing

We now have an isometric dragon drawing that exists within an isometric perspective.

Creating Turnarounds

Rotating a character is commonly used in animation, toy design and illustration. The character is typically drawn in several positions: in profile, from the front, from a quarter view and from the top or back. This is important because designs in these fields often need to remain consistent from every angle. You don't want your dragon looking like a different dragon altogether once you turn it to the side. Rather than starting off with a dragon head to explain the basic different angles, we will use some colored cubes to demonstrate the concept (and to lead into a helpful exercise to strengthen your turnaround skills).

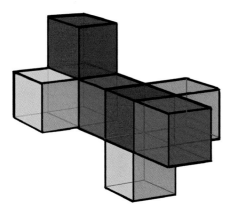

What's an Orthographic Angle?

An orthographic angle is a projection of a 3D form into a 2D space. Our subject is still a 3D object, but we are using orthographic projection to get the benefits of viewing it from a highly restrictive angle. This can help isolate specific details.

Three-Quarter View

You usually want to start a turnaround sheet with the three-quarter view. This way, you will get the most information about the shape's details before moving onto the more orthographic angles.

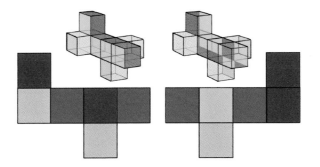

Front and Back Views

The second-most information-rich spot on this cube chain is the front and back region. Determine the width and height of the cube segments based off the three-quarter view. Since a cube is equal on all sides, these dimensions should remain consistent for all the other rotations. Remember, this (and all the next angles) are orthographic, so we should not see any hint of another viewpoint in the same angle.

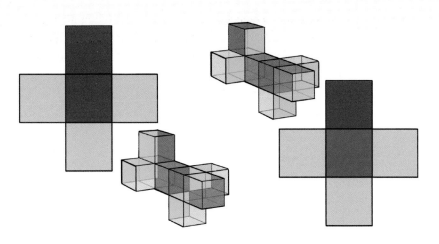

Left and Right Side Views

Side views are very important. A character may look decent from a front or quarter view, yet look bizarre when turned to the side. This is to be expected, even with our cubes, as we're cut off from the bulk of our shape! If we notice anything iffy when turning our character to the side, like a floating eye or a poorly fitted mouth, we may consider some character design choices. Turnarounds are all about "fixing as you go" in terms of design, but remember to update any changes onto all your angles.

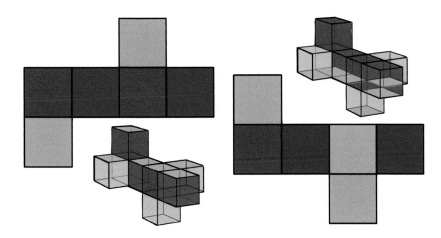

Top and Bottom Views

For 2D animation, the top and bottom views are often disregarded. For 3D animation, it's far more necessary. In this cube chain we have some projecting cubes. Because they are equal in dimension with the other cubes, they would look perfectly flat when laid out as a top and bottom angle with no indicated projection.

Exercise 4:
Practice Rotating Cube Chains

Rotating cube chains can help you to better understand how to rotate your dragon characters. Draw a random assortment of interlocking cubes at a three-quarter view. When you're done, draw the orthographic angles for side, front and bottom views. If this is too easy for you, add more cubes at odd angles to the chain to challenge yourself.

Dragon Bust Turnaround

Now that you understand the basic rotation angles, you can move on to applying them to an organic shape—like a dragon's head. In the following example, we will rotate a side, front and three-quarter view for the head. Start with the three-quarter view!

Front views **(B)** always look a little unnatural—for good reason—you'll scarcely ever see 3D characters directly from the front. However, they are necessary to understanding the form of the design.

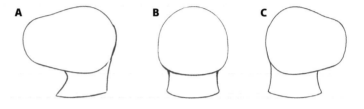

1 Draw Basic Shapes

Determine the three-quarter shapes for your dragon bust at the far right of your page. Once finished, use a ruler to create a straight line across the paper at the top and bottom of the head shape, as well as the curvature on the bust's bottom. This will allow you to determine how to create the front and side views.

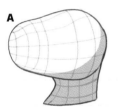
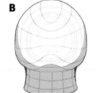

Side busts **(A and C)** are the same, only mirrored. Most times, characters look identical on their sides, but this isn't always the case. Some might have a horn on their right side that's not as tall as the one on the left, so be sure to include both right and left turns.

2 Create Volume

Determine the desired volume for the three-quarter view head shape. Use your pencil to draw the grid lines to change this from a 2D shape into a 3D one. Feel free to add some light shading to help push the 3D feel some more. Once you're finished with the three-quarter bust, place your ruler over the top of each grid line and then translate that to the front and side views.+

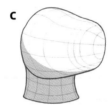

3 Add Details

Add detail to the three-quarter bust, such as the eyes, mouth lines and contours. Once you're satisfied with your head's details, again use your the ruler to translate the new details to the other busts. Anticipate making mistakes and keep re-working details until it starts to look accurate.

Mediums

A drawing medium is any tool that you can use to create artwork. There are generally two categories: traditional and digital. Traditional mediums involve hands-on materials such as sketchbook paper, watercolor paints, clay—basically anything physically tangible. Digital mediums involve technology, such as a drawing tablet or Photoshop. Often, artists use both types, as each has advantages and disadvantages. With traditional artwork, an artist can sell an original piece. Whereas the value of an individual (noncommissioned) digital piece is generally cheaper, since you can make as many copies as you please. However, with digital artwork, you can typically work much faster than you can with traditional means, which is why digital mediums are widely used for professional work.

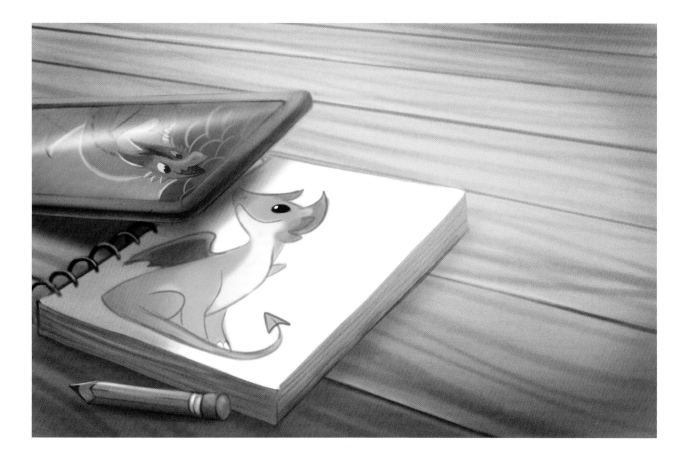

Pencils

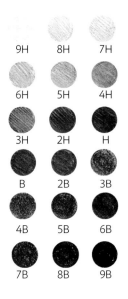

Pencil Basics

Although there are quite a few pencil grades, ranging from 9H–9B, you'll often only need pencils between 2H and 2B for general sketching and drawing. H pencils are harder and lighter while B pencils are softer and darker. If you're creating a highly detailed pencil drawing, you'll probably find the entire range of pencils to be useful, but we won't be covering that in this book.

Pencil is about as basic as you can get in terms of drawing material, and it's the tool of choice for almost every artist in the beginning. Graphite pencils range from the lightest 9H pencils to the darkest 9B pencils. If you're trying to sketch something very lightly, it would be better to stick with a light pencil, while you would typically want to use something stronger for shading purposes.

Colored pencils don't generally have a scale from 9H–9B. Instead, you just have darker and lighter hues of varying colors. So, if you want to shade a character, you would have to use darker colored pencils and blend them into the lighter ones. Even the cheapest colored pencils can blend.

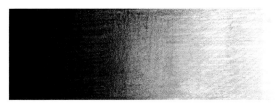

Shading

When shading with pencils, be sure you understand how to apply pressure to that particular pencil type so you can use its full range. Practice this by shading from absolute dark to light. Try it a few times with the same pencil until you get the hang of it and feel confident enough to apply the shading to your pencil artwork.

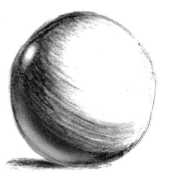

Lifting Graphite to Lighten

You can lift the graphite off of the paper to create highlights and lighter spots on your drawing. Use a small, soft eraser, such as a kneaded eraser or something similar, and gradually reduce the amount of graphite in the areas where you want the highlights.

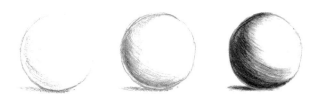

Layering

Even if we're not using a digital program, we can layer our pencil shadings by splitting the process into rounds of shading that get gradually darker. Start off with light shading along the edge of a sphere and work your way toward the center with each new layer of shading. This gives you better control of your shading.

Draw a Dragon Using Pencils

In this example, we will be sketching a dragon using only pencils.

1 Sketch a Dragon
Sketch out the dragon with light pencils (preferably nothing darker than an HB). In this example, I used an H pencil to lightly sketch the figure of the dragon and an HB for the contours, eyes, claws and lead bits.

2 Add Scales
An HB pencil is perfect for drawing smaller dragon details, such as the scales. Keeping the pencil relatively sharp, draw rows of scales onto the creature. Using the same pencil, lightly shade the soon-to-be darkened areas, such as the belly scales, the nose tip and the claws.

3 Apply Shading
Use a 2B to shade the scale area on his body. Take care not to smudge your drawing with your hand. Pencils that have darker leads are easier to smudge. Those smudges can sometimes be difficult to erase.

4 Add Depth and Highlights
Use a 4B to darken even further for more depth. The areas underneath the chin and below the knees are almost black. Don't overdo it, and be sure there is a light source. Using an eraser, lift graphite to give the impression of highlights over the scales of his back.

Colored Pencils

In the following example, I used Faber-Castell colored pencils, but you should feel free to use whatever brand works best for you.

1 Sketch a Dragon
Create a very light impression of this sketch using a 9H or H graphite pencil. Trace over the graphite lines using a darker colored pencil. In this case, I used a dark purple, a dark orange and a dark blue.

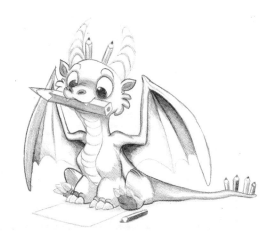

2 Add the Shadows
Now draw the position of the main shadows. We'll assume the light source is coming from the top and start creating the shadows from the bottom up. We'll add colored shading along all of the pencil lines as a starting base. Use a colored pencil that is a little lighter than the dark lines, but not too much lighter, to blend out the shadow areas. In this case, I used a medium orange, a purple and a blue.

3 Blend Light Areas with Shadow Areas
With shadows sorted, use lighter colored pencils to fill out the white areas. When you reach the shaded parts, continue coloring into them to get a nice blended effect.

4 Add Final Color
Use your darkest, medium and lightest pencils to add another layer of color on top of step 3, blending as you go. Next, apply color in the opposite direction to cover any small white spots.

Markers

Markers are often used by manga and comic artists. They're a little trickier (and generally more expensive) to get the hang of, but they do have an almost digital-like appearance when done correctly. In the following example, I used Ciao Copic markers.

1 Sketch a Dragon
Sketch the dragon using a light 9H or H pencil. When the form is solid, trace over the existing sketch using a fine liner pen. When finished, erase any visible pencil lines from your drawing.

2 Apply Shading
Identify the darkest points of the drawing. The darkest points will be those points with the least light exposure (typically around edges and points where joints form folds). Then use a medium purple and a dark blue marker to add shading to those points. Use a medium pink to define the shadow on the edges of the belly scales and a medium green for the contours of the horns.

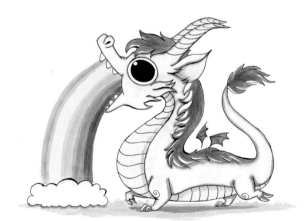

3 Add Color
Much like the colored pencil example, color within the drawing to get rid of any white areas. Focus on blending these stark colors together in the polishing stage.

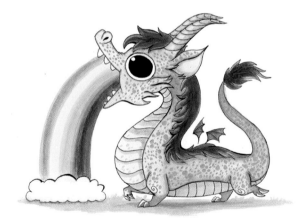

4 Add Details
Add more darkened areas by overlapping them with another color. For the mane, blend a dark blue into the dark purple to give a better impression of depth, keeping the hair tips lighter, as they are more exposed to the light. Also blend together the lighter blue and darker blue of the body to make it more three-dimensional.

Mixing Mediums: Sketch to Digital

As I mentioned earlier, some artists like to mix traditional and digital mediums, often coloring a sketchbook sketch in Photoshop. In this demonstration, we will cover how to get a sketchbook drawing onto your computer and into a digital program, as well as the basics on how to paint over a scanned sketch in a digital program.

1 Import Sketch to Photoshop

In this scenario, we've completed this inked dragon drawing and need to get the sketch into Photoshop. If you don't have a scanner, you can always take a photograph of the sketch. While a scanned sketch will always translate better to digital than a photograph, there are many phone apps available (like CamScanner) that will digitally flatten a photograph like a scanner would.

2 Add Line Contrast

Now that the sketch is in your digital program of choice, you can use the program's tools to digitally add contrast to your lines. This will make the sketch look more like line work that was created using a digital program. If you're using Photoshop, go to *Image > Adjustment > Threshold* and experiment with the levels to get crisper lines.

Zoom In

Enlarge your image on the screen to see the small details for better cleanup.

3 Clean It Up

Even if your drawing program doesn't have access to similar photo-adjustment tools, you can still clean up the drawing manually using a white brush on top of a new layer over the scanned layer. Try zooming into the image to check for any bits to erase. You can even "cheat" a little by hiding any mistakes you may have made while inking the sketch traditionally.

4 Add Color
To begin adding color to the sketch, create a new layer on top of the scanned layer and set it to Multiply. Most programs will have this option. Then you can color your sketch without coloring directly over your scanned lines.

5 Add Another Layer
Add another layer (also set to Multiply) to further render the character as you would with any other digital drawing. Now your previously traditional sketch is almost indistinguishable from digital art.

One Last Trick

In Photoshop (and some other art programs) you can color your inked lines by following these simple steps: Create a blank layer above your scanned sketch layer. Set this layer to Screen. Then, by brushing over your lines, you can change their color to anything you'd like.

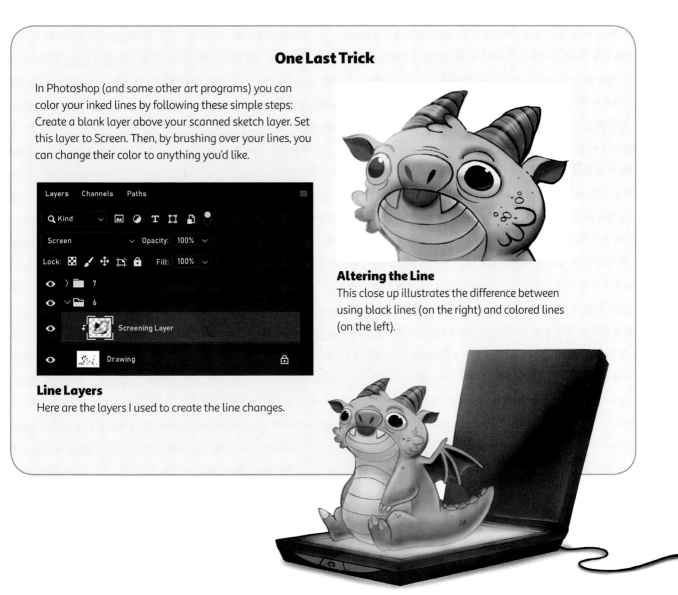

Altering the Line
This close up illustrates the difference between using black lines (on the right) and colored lines (on the left).

Line Layers
Here are the layers I used to create the line changes.

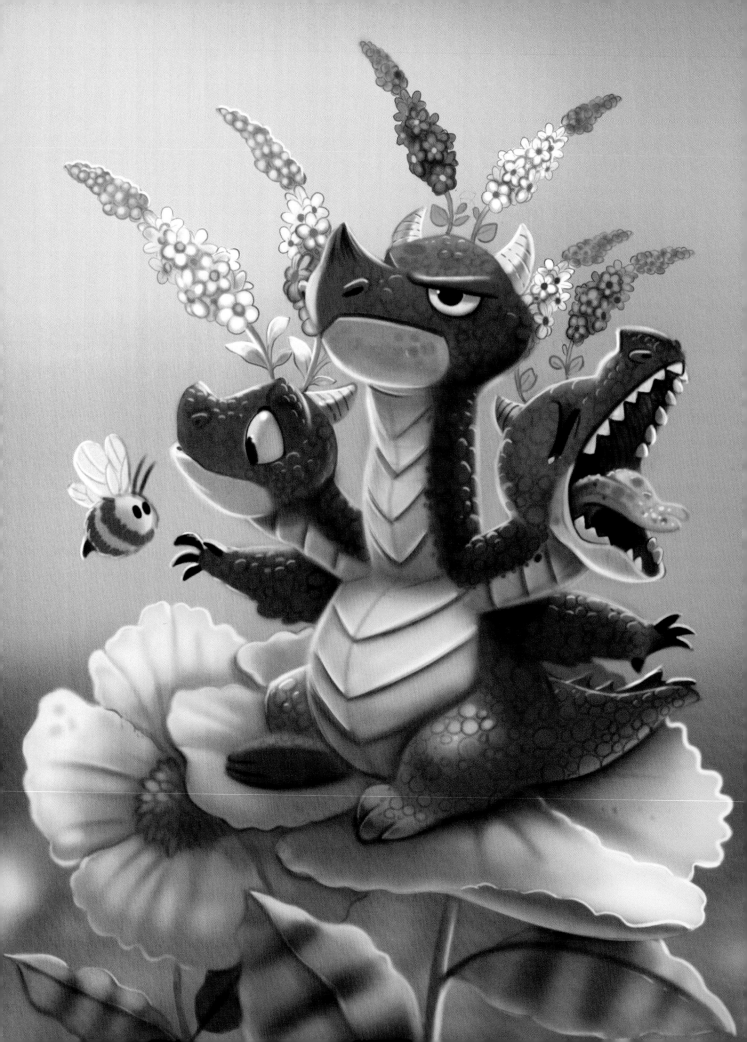

2 Designing Dragons

Now that you've learned the basics of how to draw, you can move on to learning how to design your dragons. In this chapter, we will learn the basics of dragon designing: from shape language and expressions to anatomy and poses.

This content focuses heavily on the animation "pipeline" of character creation. The following series of steps would be similar to the steps taken to design a character for animation. However, this pipeline can be used for just about any project.

- **Shape design** focuses on conveying personality through the use of shapes for characters. Shapes can range from spherical, for a quirky roly-poly sidekick, to angular, for a ferocious-looking dragon.
- **Expressions and poses** are all about getting your character to act. Poses can, and often do, speak just as loudly as facial expressions, and we will cover how to create lively ones!
- **Dragon anatomy** is a very important subject. Learning it will enable you to draw dragons with a proper skeletal and muscular frame.

So let's start designing!

Basic Shape Language

Now we're into the fun stuff! Shape designing is a common design theory that is often used in the animation and illustration world. To sum it up, humans interpret characters in a certain way based on how round or how sharp they are. In a way, it's like combining human psychology with design, which will come up again when we get into using color. Using shape theory can help us create characters that reflect personality from the first glance.

Circle Shapes

Humans are programmed to find round things cute. This is because round = human babies. Round bodies, short limbs and big eyes evoke an empathetic response. This is why, despite the general reputation of spiders, many people find jumping spiders adorable. Personality-wise, round characters are generally naive or mischievous.

Square Shapes

When you think of a square, you think of sturdiness; something that cannot be easily moved. These characters read as having strength. Personality-wise, they are generally intimidating or protective.

Triangular Shapes

On a subconscious level, we know that sharp = danger. This is why sharp designs in villain characters are quite common; they invoke in us a sense of unease. Personality-wise, they are generally short-fused or cunning.

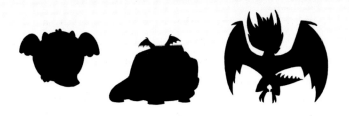

Character Silhouettes

A silhouette is an image that is represented in a single color, usually black. Although we design characters with detail, it's important that they read well when seen as a silhouette. If you can't tell your characters apart from one another as silhouettes, or if they're too blob-like or convoluted, that's a sign of bad readability. Think of pop-cultural characters like Mickey Mouse, Mario and Pikachu: if you only saw them as black silhouettes, you would still be able to identify them.

Shape Designs Are Not Rules

Shape design is not a fundamental rule of character design, so it's fine to create a character that deviates from these baseline ideas. For example, there are designs that are round and villainous (Jabba the Hutt, for instance) or sharp and friendly (like a kind porcupine character).

Negative Space

Negative space is the area around your main subject. When designing characters, be cautious about how you angle them and whether enough defining detail is visible. In this example, we can clearly read the dragon's design on the left, as there is sufficient empty space around it, and the shapes are defined enough for a quick read. The dragon on the right, however, is blob-like and difficult to identify.

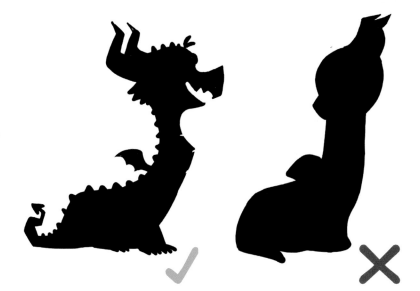

Designing a Character

Now let's learn how to take a character from sketch to finished design. We will start off by gathering photo references, creating multiple sketches, then honing our selection so we can move onto adding color for our final sketch. This is a condensed version of what actual character design usually entails. Designing characters sometimes requires hundreds of sketches. For this example, we'll stick to a few.

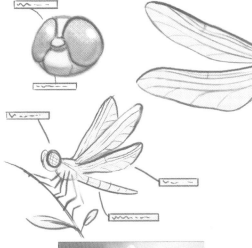

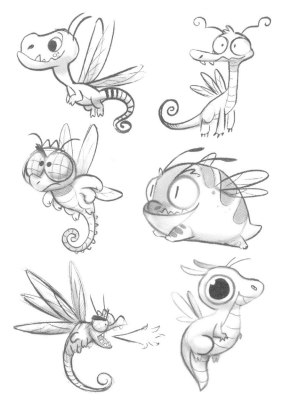

1 Research Your Subject

It's important to start with research into your subject. Look for inspiration to generate ideas. If your character is based on an animal, gather photographs of that animal. If they're from a certain time period or location, collect relevant photos of or based on that time or place. You can gather references using Google Images, Pinterest or your local library.

2 Explore

Using the references you found as guides for inspiration, you can conjure better ideas for your character design. For example, by knowing how dragonfly wings and bodies work, we can play around with that concept as much as we'd like until we discover the best option. Explore more than just a simple standing pose. It's easier to picture the character as real if you explore it through poses and expressions. In this example, I selected the dragon on the bottom left because it has an interesting silhouette and reads more efficiently than the others as a dragon/dragonfly combo based on his anatomy.

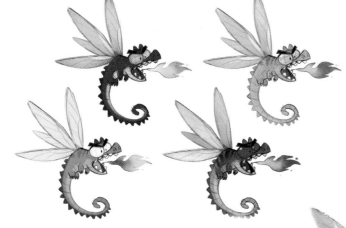

3 Experiment with Color

When you're comfortable with a design, use that drawing to experiment with different colors before committing to a final palette. References for dragonfly colors still come in handy at this point. In the end, I felt the last sketch had the most interesting mix of colors from the bunch, with blue and yellow contrasting nicely, so I chose that one.

Exercise 5:
Create Shape Dragons

Create three dragons based on round, square and triangular shape designs. Once you're happy with them, pick your favorite design. *Important Note:* The dragon design you choose will be used in future exercises, so choose wisely!

4 Final Render

With your final color selected, you can create a painted final sketch to demonstrate how your character may look in its medium of choice. In this example, the dragonfly would be a CG animated dragon, so we paint it to appear 3D. If you wanted your character to remain 2D, then you would paint it accordingly.

Dragon Eyes

Eyes are a particularly important part of developing your dragon's expressions. Two characters may both express anger, but it would be dull if they did so identically. This is where the acting bit comes in. Think about how and why this character reacts in a particular way, and how its eyes look when they do.

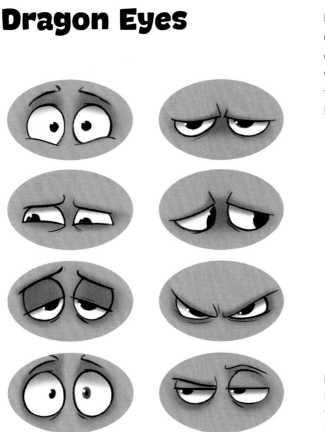

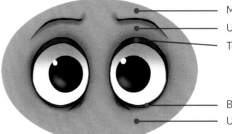

Middle Brow
Under Brow
Top Eyelid

Bottom Eyelid
Under Eye

More Than Just Eyeballs

Note that the eyes, eyelids and brows aren't the only focus when creating expressions. The skin surrounding the eye is just as important. Many expressions use the upper and lower eyelids to convey the emotion. Think of a typical disgusted face: The squinting eyelids convey revulsion.

Drawing Eyes from the Side

If your character has forward-facing eyes (like a human), then the view of the eyes from a side angle should not form a perfect circle. They should be visible from the side, but the eyelids should cushion the eyeball to create a tapered corner.

Creating Dragon Expressions

Following are examples of a few basic expressions and the typical facial reactions that occur when they're performed. Note that these are not rules, so there may be many exceptions. A good way to explore expressions is to perform them yourself before you draw them onto your characters. Having a mirror handy when you draw can help you understand subtle facial intricacies.

Expressions Infuse Personality
Each character expresses itself in a unique way. Of course, not all dragons need to be expressive. They can be animalistic and expressionless. Giving an animal character expressions is *anthropomorphism*, or infusing your design with human traits.

Happy

Eye region: The eyebrows may be raised slightly.

Facial region: If the smile is wide enough, skin will cushion between the eye and lip.

Mouth region: The sides of the lips curl upward.

Sad

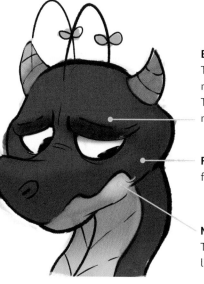

Eye region: Varies. The eyes may remain neutral, droop or close. The brows can be neutral or furrowed.

Facial region: The face is relaxed.

Mouth region: The sides of the lips curl down.

Angry

Eye region: The brows furrow together deeply and can overlap or partially eclipse the eye beneath it.

Facial region: The skin in the center of the face is usually compressed, depending on the intensity of the mouth expression. Wrinkles may form on the nose.

Mouth region: Varies. The mouth may be snarling, yelling, have clenched teeth or be neutral.

Surprised

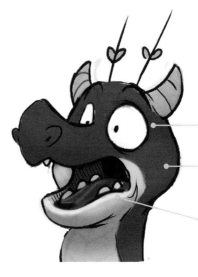

Eye region: Varies. The eyes may remain neutral, droop or close. The brows can be neutral or furrowed.

Facial region: The face is relaxed.

Mouth region: The sides of the lips curl downward.

Disgusted

Eye region: Varies greatly. There can be a quizzical brow, with one eyebrow descending while the other rises, or it can remain neutral. The sneering from the lower face may push some skin up between the brow.

Mouth region: Varies. The tongue may stick out or the lips may curl up in one direction.

Facial region: If very disgusted, the nose may retreat upward, pushing up some cheek skin in the process.

Annoyed

Eye region: Very important. Eyes may have a descended eyelid or a descended brow. They often appear to be aloof, which can make the character look deep in thought, or they may be rolling their eyes in exasperation.

Mouth region: Varies. Can be a stern frown, a grimace or a neutral mouth.

Facial region: A grimace may push skin downward below the lips and along the chin line.

Laughing

Mouth region: Both sides of the lips curl into a wide, open smile. Teeth are often exposed. The interior of the mouth may be visible, depending on the intensity of the laughter.

Eye region: Varies. The eyes typically have skin from the cheek bunching up beneath them, which may cause a squint. The eyes might be closed altogether.

Facial region: Cheeks push up to compensate for the wide-open smile, bunching the skin under the eye.

Exercise 6: Create Expressions

Use the dragon drawing you chose from Exercise 5 and create a sheet of ten different expressions for that dragon. Try any expressions you like. They don't have to be the same as the ones shown here.

Crying

Mouth region: Varies. If the crying is subtle, it might not move at all. If the crying is moderate, the lips might curl downward. Intense sobbing may result in an open mouth.

Eye region: This expression is dependant on the eye region. If the crying is subtle, the eyes might be neutral with some reddening and forming tears. If the crying is moderate to severe, the eyes may be shut tight with tears streaming down and furrowed brows.

Facial region: Varies. If the crying is subtle, it might remain neutral. If the crying is moderate to severe, the cheek region may push up skin.

Gathering Reference

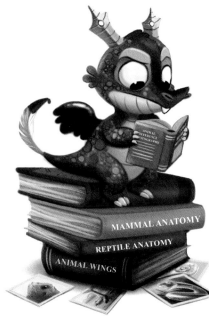

Dragons have always been based on animals that humans have encountered in the real world, from reptiles to snakes to big cats or birds. Getting a grasp on animal anatomy will make your dragons more believable.

There are many animal references available online. Just make a quick Google search for "[insert animal name] anatomy" and you should be able to easily find references for bone structures, muscles and more. There are also entire books devoted to animal anatomy that are worth picking up.

Organizing References

When beginning any dragon drawing, it's a good idea to create a reference library for that dragon. This may vary in size, depending on the magnitude of the illustration. If you're going to set out to work on a drawing for 30 minutes, you need not use as many references as you might need for a 30-hour painting. And remember to keep the layers organized! In this example, the reference library is kept within a separate layer group titled "References" in Photoshop, with a subgroup that includes specific references for each part of the animal. This allows for quicker access to the images while you work, but you can form your own reference system to your tastes.

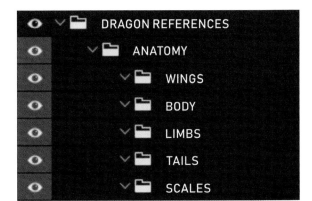

How to Set Up a Reference Library

When using Photoshop, you can create a group layer by clicking the folder icon on the bottom bar or going to *Layer > New > Group*. You can rename it by clicking on the Group Layer's text. Drag the contents underneath this layer, be it a single layer or other group layers that you would like to use as subgroups.

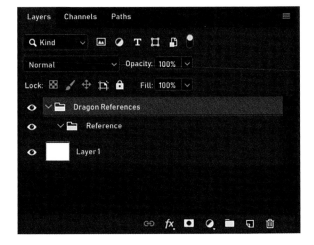

Anatomy Choices

You're not bound to using limb anatomy that matches up with humans or cats. Look up a variety of animals to generate ideas for how your dragon's particular anatomy will function. Consider the specific evolutionary advantages of your dragon's features.

More reptile-like
More mammal-like

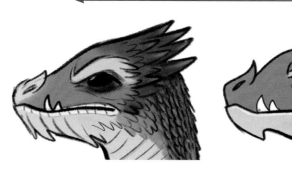

Reptilian vs. Mammalian

Historically, dragons have been presented in forms that look similar to reptiles alongside interpretations that appeared almost lion-like. There is no strict rule concerning which is better. You can always try to find a middle ground between reptile characteristics and mammalian ones.

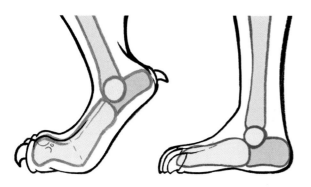

Plantigrade vs. Digitigrade

Humans are a plantigrade species, meaning they walk on the soles of their feet, as do bears. Dragons are rarely represented as having plantigrade feet, but more anthropomorphic dragon interpretations may take this form. Instead, dragons are often represented as a digitigrade species, meaning they walk on their toes like feline and canine species.

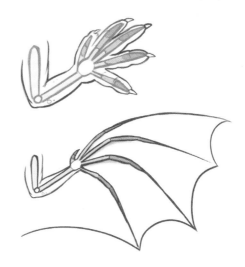

Dragon Limbs Can Take Many Forms

In nature, not all reptiles have similar limbs and digits. For example, a gecko has bulbous fingertips to improve its grip on surfaces while an alligator has bulkier claws to drag their massive bodies along the ground.

Dragon Anatomy

Anatomy is the bodily structure of living organisms. In art, we usually focus on the skeletal and muscular systems of animals and humans. Most vertebrate animal skeletons follow a similar basic template: one head, one spine, two forearms, two forelegs, one rib cage and one pelvis. Over time, natural selection can shift, enlarge and shrink the bones of this template to better help a creature survive, but nature seldom adds brand new limbs for vertebrates. And four limbs is plenty for balance and speed. Western dragons, like the following example, are typically shown with another pair of arms for wings. This may be fantasy anatomy, but if we're aiming for any sense of realism, we should understand its form and function.

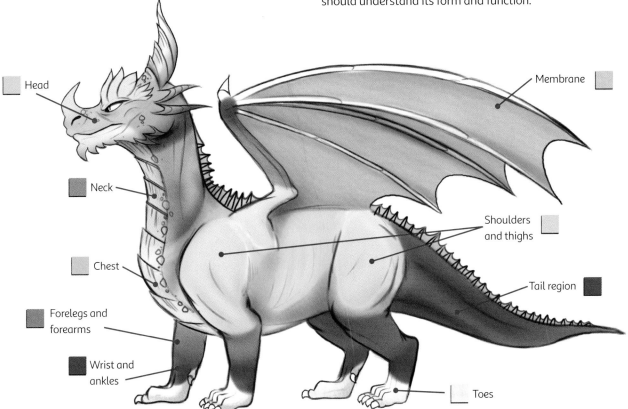

Head

Neck

Chest

Forelegs and forearms

Wrist and ankles

Membrane

Shoulders and thighs

Tail region

Toes

Understanding Dragon Anatomy

Drawing an animal or human can be daunting, and figuring out the underlying anatomy even more so. For the sake of keeping things simple and organized, look at the dragon as several major segments.

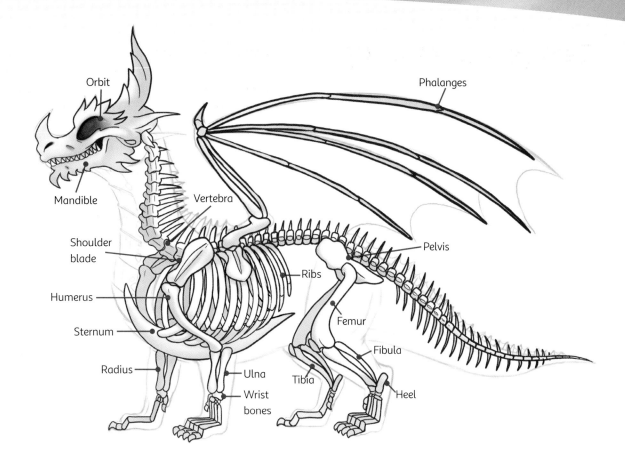

Orbit

Mandible

Shoulder blade

Humerus

Sternum

Radius

Ulna

Wrist bones

Vertebra

Ribs

Tibia

Femur

Fibula

Heel

Phalanges

Pelvis

Skeletal Anatomy

A dragon's skeleton consists of many different types of bones. Understanding its underlying structure will help you pose your dragon without making its body look deformed. This dragon is primarily based on canine, bird and bat anatomy. It has digitigrade legs, a canine skull, an enlarged sternum and an extra pair of limbs for wings. The enlarged sternum is modeled on a bird, which provides an anchor for the wing muscles and better flight. The extra pair of limbs (though not realistic) are positioned behind the front shoulders and, similar to a bat's, the fingers are elongated to serve as wing fingers. To practice, study the skeletal structures of many animals (including humans), then you can easily apply that knowledge to your dragon designs!

Exercise 7: Add Features

Create a few design variants for your dragon character. Try creating five different wing, horn, tail and head designs. From that selection, pick your favorites and apply them to the dragon.

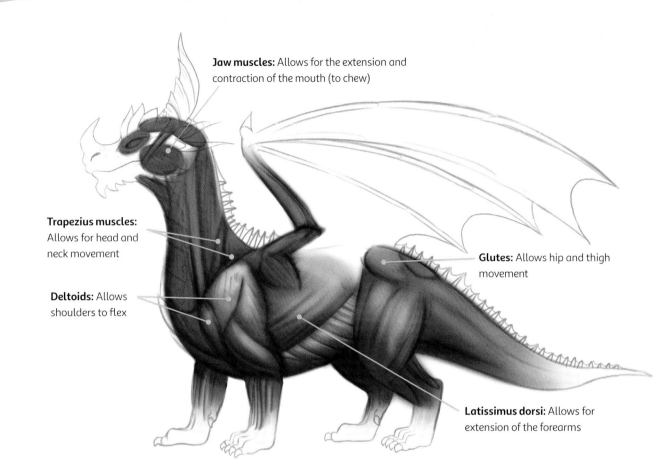

Jaw muscles: Allows for the extension and contraction of the mouth (to chew)

Trapezius muscles: Allows for head and neck movement

Deltoids: Allows shoulders to flex

Glutes: Allows hip and thigh movement

Latissimus dorsi: Allows for extension of the forearms

Muscle Anatomy

An animal's skeleton acts as an anchor for the muscles, enabling its body to move. Muscles are the source of strength in a living organism. If you want to draw a dragon with powerful wings, its wing muscles need to be sufficiently large to support its body weight (although you can always use artistic licence and keep such details unrealistic). There are many types of muscles, all of which are important and help a creature move, but we will focus on some of the most prominent ones.

Types of Muscles

Like with individual bones, dragons contain many different muscles. These can be divided into muscles that flex and muscles that extend.

- **Extensor muscles:** Muscles that extend outward. When you run, your hamstrings will extend out.
- **Flexor muscles:** Muscles that contract inward. Also when running, your quadriceps will contract inward.

The ebb and flow of these two muscle types allows for walking, running, jumping and flying movements.

Dragon Wings

Dragon wings are one of the more difficult aspects of dragon anatomy. Since dragons aren't real creatures, we have to improvise how dragon wings look by referencing animals in the real world. Of course, you can absolutely get away with drawing slapped-on/cartoony dragon wings, but if you would like something more traditionally dragon-looking, then this segment is for you.

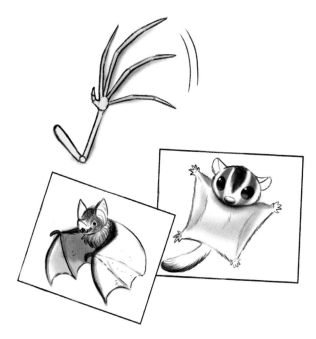

Familiar Structures

Think of a dragon's wing as you would a human hand that just happened to have membranes running between its fingers.

Use Animal Anatomy to Understand Dragon Wings
You can gain a better understanding of dragon wings by observing how the wings of flying reptiles and mammals work. This will enable you to understand the underlying bone structure of our fantasy beast. For the following examples, I will use bat anatomy.

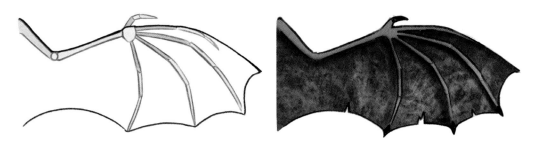

Drawing Dragon Wings
While you do not need to draw a visible thumb in the wing, dragon wings should not be random membrane. The lines you typically see in a dragon's wings ought to be its fingers, enabling it more control over flight. Realistically, like most flying animals, a dragon's wing membranes should follow along most of its body. This is sometimes ignored for the sake of stylization, but it's good to keep that principle in mind if you're aiming for a realistic dragon.

Dynamic Poses

Dynamic poses are character poses that display action. Static poses are character poses that are unmoving and neutral. Neutral poses have their place, of course, but if you want to evoke your dragon's personality, dynamic poses are a necessity. Even a realistic dragon would look better in action. Just imagine a ferocious snarling dragon defending its gold hoard from dwarves, raising its wings and arching its neck to torch its enemies with fire versus a dragon sitting on a mountain with no purpose.

Here are some things to keep in mind when creating dynamic poses for your dragons.

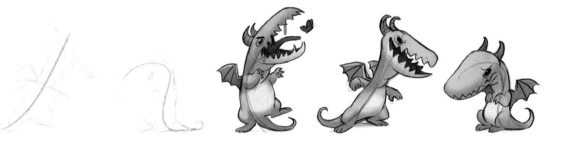

Action Lines
Action lines are curved lines that express the path of movement in a character and capture the energy of the pose. Keep a flow going for the curve. You don't typically want a straight red line (unless intentional), or the pose will be static rather than dynamic. Action lines are normally represented as a C or an S curve. As demonstrated in this example, the energy line on the dragon forms a C when startled and an S when crouching.

Counterbalances
When we stand, our weight is rarely evenly distributed. We're bendy creatures and no one is truly stick-straight. Counterbalancing is when the hips tilt left or right, which typically shifts the shoulders in the opposite direction.

More to Acting Than Just the Face
There is a lot more to acting that just using facial expressions. A character may have no face whatsoever, like the magic carpet in *Aladdin*, and still manage to convey emotion through movement. Even if you can easily draw expressions for your dragons, don't rely heavily on faces. A character is better expressed through movement and expression together.

Creating a Dynamic Pose

Now let's create a dynamic pose of the dragonfly character carrying a heavy object. This pose should be either a C or an S shape.

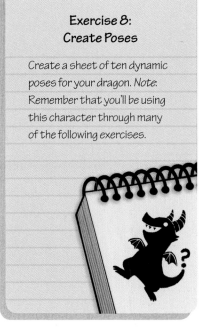

Exercise 8:
Create Poses

Create a sheet of ten dynamic poses for your dragon. *Note:* Remember that you'll be using this character through many of the following exercises.

1 Draw an Action Line

Draw a curve for the action line, along with two counterbalancing lines that will become hips and shoulders. Consider that the character is holding an object behind himself before you start the lines.

2 Create the Rib Cage and Pelvis

Pencil out a rib cage and pelvis along the form of your line. Ideally, these should look 3D to get a better idea of the character's overall position.

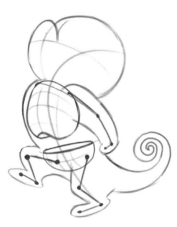

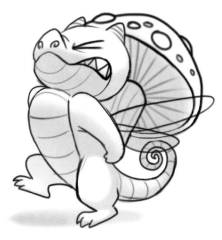

3 Add the Limbs

Pencil in the basic form along the action line's guidelines. Include limbs coming off the shoulders and hips. You can draw the limbs straight away, or you can draw lines as makeshift limbs to experiment with where the limbs can go without wasting time erasing the drawing.

4 Finish

Complete the drawing and erase the underlying work. Be sure to "clothe" your drawing over the skeleton base you've created. Try to maintain the energy of the pose you've established as best you can. Feel free to ink the drawing and use marker to lightly indicate the dragon's forms. Don't get carried away with detail. These should be quick sketches, as you will usually have to draw quite a few of them.

Environments and Scenery

Dragons, like animals and like us, have to have a place to sleep, eat, hunt and play. Although drawing backgrounds may not seem as dragon-related as learning how to draw wings and scales, learning the basics of environment drawing will improve your dragon illustrations tenfold. Sure, you can draw and paint your dragons against a white backdrop if you please, but they will look far more interesting if they are flying across a tree-covered fjord.

 Ideally, if we wish to include a background, we would think out our dragon's environment before starting our dragon. We needn't sketch it just yet—or even before our dragon drawing—but it's important to consider while we're sketching our dragon, otherwise the background may end up feeling slapped-on. As a rule of thumb, if the background is very simple (like a dragon against a sky) you needn't put much thought into it at the beginning stage, but if you're going to draw a dragon flying past castle ruins, you'd best create a small thumbnail sketch beforehand.

Background: Area in a scenery that is the farthest from the viewer.

Midground: Area in a scenery that is between the background and foreground.

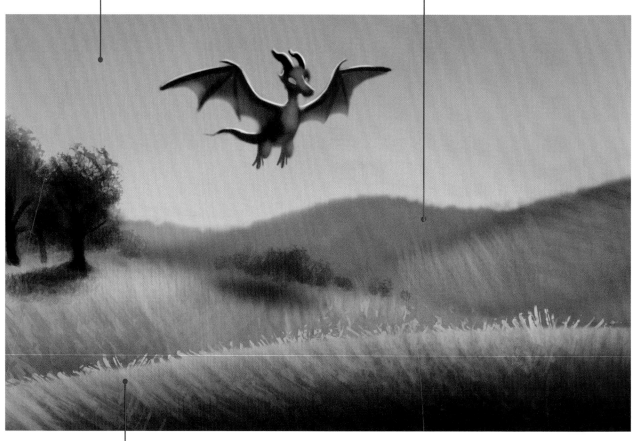

A scenery is comprised of three grounds: background, midground and foreground.

Foreground: Area in a scenery that is the closest to the viewer.

Skies and Clouds

As we all know, skies aren't always blue and clouds aren't always bright, white and puffy. The color of the sky changes depending on how the sun's light interacts with the atmosphere. Clouds are formed from miniscule water particles and ice crystals, which have different shapes depending on their temperature and altitude. Some examples of different, and commonly seen, types of clouds are cirrus (puffy, like the example), cumulus (thin) and stratus (sheet-like).

1 Create a Sky
This dusk setting has a gradient between turquoise and a tawny yellow. By adding a (slightly) lighter color, you can add some faded background clouds.

2 Create the Cloud Shapes
Using a solid brush, shape the main cloud shapes. Avoid uniform cloud lumps to make it look more organic.

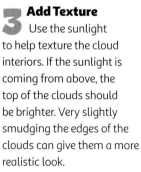

3 Add Texture
Use the sunlight to help texture the cloud interiors. If the sunlight is coming from above, the top of the clouds should be brighter. Very slightly smudging the edges of the clouds can give them a more realistic look.

4 Blend
Lightly blend some of the bluish-green sky color into the clouds. The bottom of these clouds are also getting a little too straight. Use a light airbrush or smudge tool to mix the bottom points with the rest of the sky.

Forest

Forest scenes are often dark in hue because the environment is sheltered by trees and foliage. When creating a forest scene, we can use the scarce light to our advantage to bring out focal areas in the painting and lead the viewer's eye. Light coming from beyond the trees can hit your dragon in a way that attracts more attention.

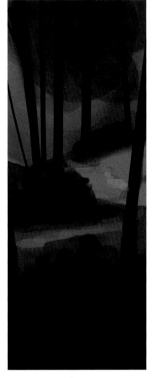

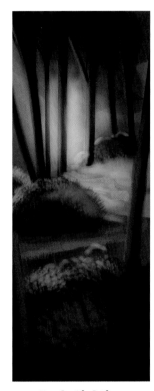

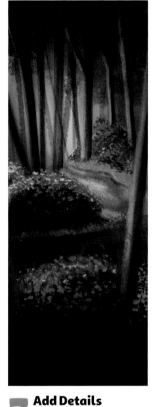

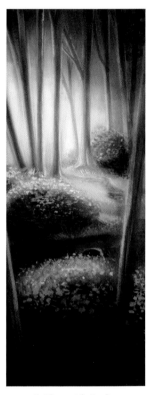

1 Establish the Grounds

Using a hard brush, layer the grounds of the painting. Start with the background and move gradually toward the foreground. After you establish the grounds, add details such as bushes, trees and a trail. Create basic shapes at this stage; do not get caught up in the small details yet. Straight lines can be trees, and a blob can serve as a bush.

2 Apply Lighting

Now you can focus on how the light pours into the scene. It's coming from the background. Make the midground area lighter and light up bushes and tree bark that is exposed to the light. The foreground in this piece should be the darkest point because it is farthest from the light. You'll learn more about lighting in chapter four.

3 Add Details

Since the landscape is solid at this point, experiment with adding more trees in the distance and focus on smaller details to flesh out, such as the path, bush and bark. You can even add a few rocks. Be aware that the farther out the trees are, the less detail you ought to draw on them, as they are farther from sight. Keep your most defined details for elements in your foreground and midground regions.

4 Adjust Lighting

The forest was looking a little too dark, so I overlaid some lighter colors coming from the background of the forest. To compensate for this change, I lightened whatever the light was previously touching.

Water

When creating a water scene, remember that bodies of water are scarcely ever motionless—especially the ocean! The wind and currents are always affecting the surface, and we want to show this in our paintings.

1 Color the Canvas
Fill your canvas with a blue color. Simple enough, but carefully determine the perspective and angle of your water to the viewer.

2 Add Strokes and Light
Using a medium-sized brush, create straight strokes. Use a different, but similar, shade of blue to differentiate the strokes from one another. Add two lighter spots of concentrated light.

3 Add a Layer of Shapes
Add a white layer of blob-like shapes. If you're working digitally, do this on a separate layer from the water. If you're working traditionally, keep the blob shapes very faint.

4 Blend
If you're working digitally, lower the opacity of the blob lines and blend them into the surrounding sea. If you're working traditionally, blend the lines into the body of water. As a finishing touch, add speckles of white on the water's surface.

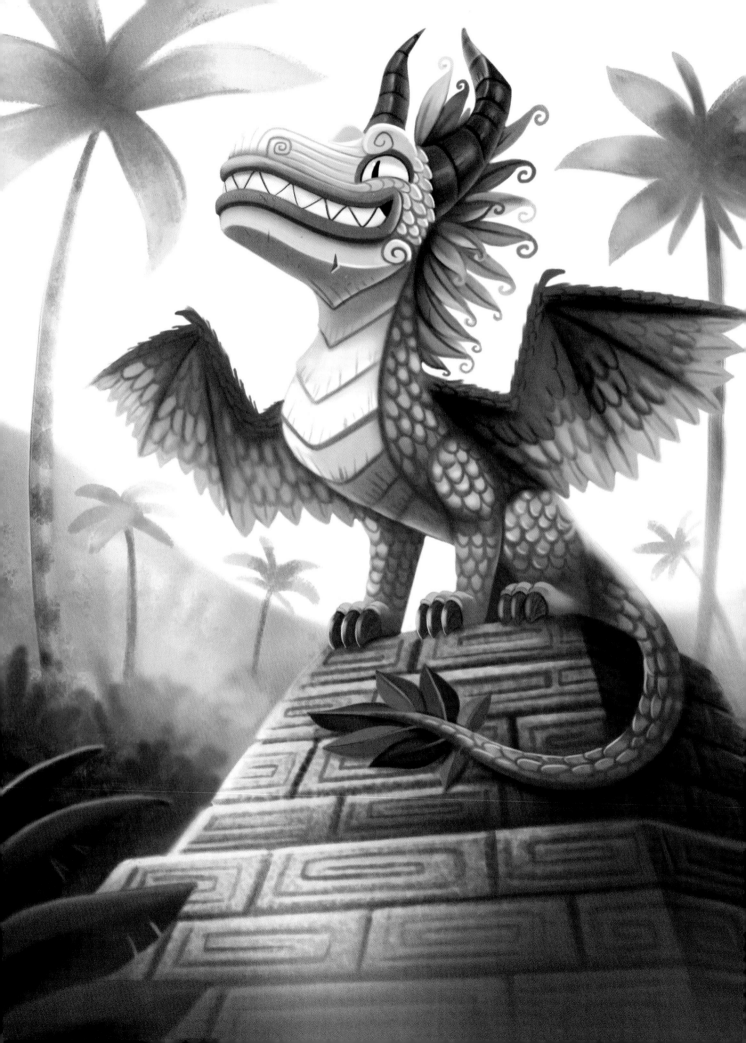

Coloring Dragons

In this chapter, you will learn about colors for dragons and their environments. Rather than focusing on painting techniques, you will learn techniques for selecting color for your artwork.

Color selection is a lot more nuanced than randomly selecting colors. A great drawing can easily be destroyed by using messy colors, as this distracts the viewer from the drawing itself.

Using the color wheel, you will learn about color schemes like analogous colors (using colors adjacent to one another on the color wheel), complementary colors (colors sitting at opposite ends of the color wheel) and triadic colors (three colors that sit equally spaced apart on the wheel). In addition, you will learn how to select an appropriate color scheme for your painting by thinking about color psychology; why we should select certain colors to convey certain moods to our viewers.

Let's get coloring!

Choosing Colors

Color is just as important to a character design as the character's shapes. **Color harmony** is a theory suggesting that certain color combinations are more pleasing to the eye than others. It is derived from our understanding of the color wheel. There are many different color harmonies, but we will focus on primary, secondary and tertiary harmonies, as well as analogous, complementary and triadic harmonies. This will give you a variety of functioning color schemes to use for your dragon designs.

It's important that you choose colors that are faithful to your dragon design. Bright primary colors can often look juvenile. If you intend to draw a baby or cartoonish dragon, those colors would be suitable. Secondary and tertiary colors would be more suitable for a wide array of different dragon designs since they can be a lot more subtle.

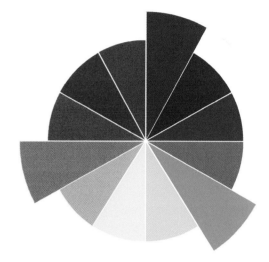

Secondary Colors
Orange, green and violet are colors that result from mixing any two primary colors.

Primary Colors
Red, blue and yellow are the base colors from which all other colors can be mixed.

Tertiary Colors
Tertiary colors are a result of mixing primary colors and secondary colors. Tertiary colors include yellow-orange, blue-green, red-violet, etc.

Stick to Your Color Draft

If you start a painting with vibrant colors rather than mono-chromatic ones, be sure to lock down the illustration's colors before starting. While you can make small color edits along the way when using vibrant colors, backtracking on a complex color scheme can be unnecessarily cumbersome because complex color schemes are difficult to edit with new colors. Simpler color schemes, especially monochromatic ones, don't typically suffer from this issue because there are fewer colors to keep track of.

Coloring Tip 1: Color Gradients

A gradient is the gradual transition from one color into the next. When working on your illustrations, you can achieve better detailing by painting "in between" two hues—essentially blending the colors. Here you can see that the dragon's yellow scaled body gradates from a medium brown to a light yellow.

Body

Wings

Horns

Claws

Feathers

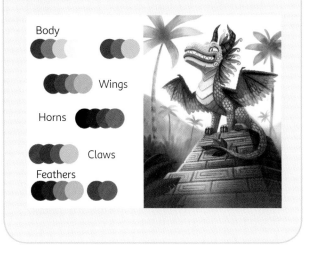

Choose a Palette

In this example, you will be exploring the color choices that lead to the final Aztec painting's palette. You will see how these color choices evolve over a process of experimentation and trial and error, and how you rarely ever get instant results. In general, the more colorful a piece, the riskier the palette. For this one, I sought to create a bright but harmonious palette.

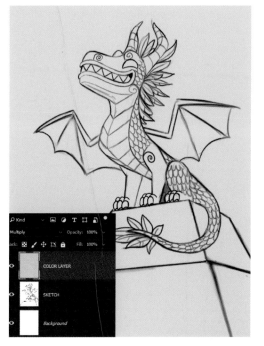

1 Start Color Thumbnails

If you're going to start a painting in color, explore the color variations of your palette beforehand. Start off with a rough black-and-white sketch of your illustration.

- For digital artists, create a new layer above the sketch layer and set the layer mode to Multiply.
- For traditional artists, create a row of at least five to seven rough thumbnails of your piece. While the coloring medium is up to you, paints will provide quicker results than colored pencils.

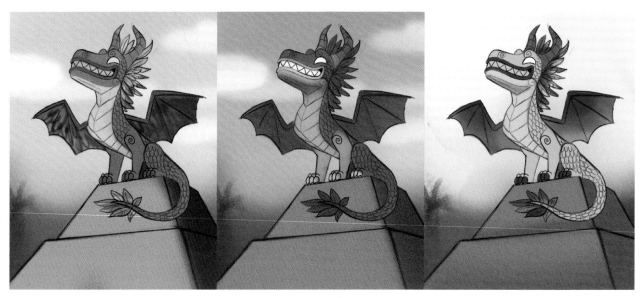

2 Make Color Variants

There is no need to make these detailed, so spend only five to ten minutes, at most, on each thumbnail. Explore color combinations that you wouldn't have tried initially. It's good to have a variety of options in the end to help you make the final selection. Think of your end goal for the piece. In these examples, the goal was to find a colorful jungle look.

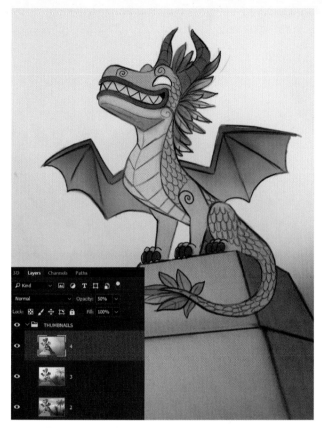

3 Mix Color Variants

Maybe you're fond of two color palettes rather than one. Experiment with blending and mixing your thumbnail colors to gain even more variety for the selection process. If you're using digital software to paint, you can generate a new color variant by stacking your thumbnails together and playing with the opacity on the layers. In this example, I lowered the opacity on Layer 4 to 50 percent, which blends it with the colors from the layer(s) below it, forming new colors altogether!

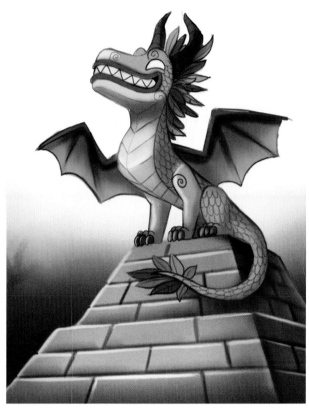

4 Select a Thumbnail

In the end, I chose a slightly different version of thumbnail 3 (from step 2) with more yellow tones. Though this is subjective, I feel the colors in this thumbnail work best for the goal of a colorful jungle piece with the focal point being the Aztec dragon. Thanks to the thumbnails, I'm confident that I did not miss out on a potentially better color palette.

Exercise 9:
Create Colored Dragon Eggs

Explore what your dragon's eggs would look like using primary, secondary and tertiary colors. Draw three rows of three basic egg shapes. Each row will represent one of the three basic color mixes.

Analogous Colors

Analogous colors are colors located adjacent to one another on the color wheel, like yellow + orange and blue + purple. When creating an analogous color harmony, we limit ourselves to three adjacent colors. An analogous color harmony should not be confused with a monochromatic one, as that would involve limiting ourselves to a single color and its tints.

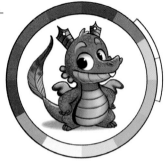

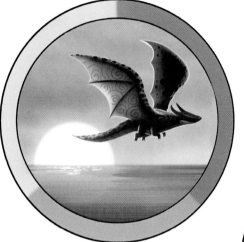

Sunset Scenes

Sunset scenes easily work with an analogous palette because of the overpowering orange hues.

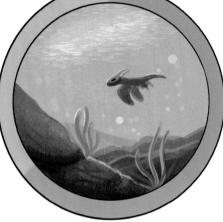

Underwater Scenes

Underwater scenes are really great for an analogous palette because red light is quickly absorbed by the water. And the farther down you go, the more color limits there are because of the lack of light.

Coloring Tip 2: The Eyedropper Tool

When painting in most digital programs, there is a hot key (typically the ALT key) that allows you to quickly pick a color from your art piece. When rendering, this hot key will speed up the process by allowing you to select previously used colors directly from the image using the eyedropper tool rather than trying to re-create them.

Analogous Colors on a Dragon

In the following example, we will color a dragon using an analogous palette from start to finish. You will learn why certain color choices were used and learn more about how analogous colors work in general.

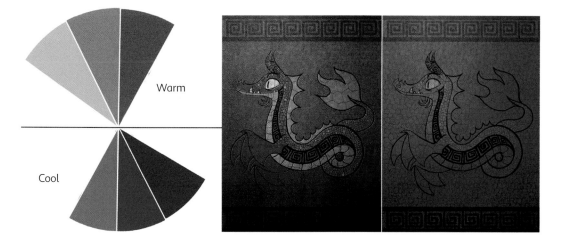

Cool Analogous Colors vs. Warm Analogous Colors

Analogous colors can range from cool to warm, with in-betweens around the middle-points of the wheel. You're free to use any of these, and you can achieve drastically different looks depending on which temperature direction you choose.

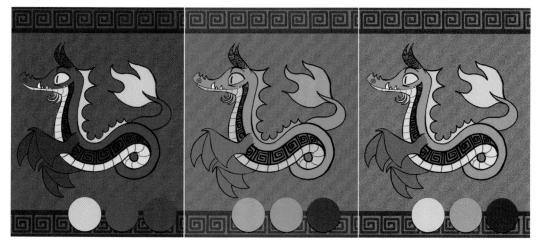

1 Make Color Variants

An analogous color variant is easy to make using a digital program. Simply take your original color draft and alter the hue in the Hue and Saturation tool. Go to *Layer > New Adjustment Layer > Hue and Saturation*. This will allow you to create a couple of diverse color variants from the original.

2 Explore Color Options

Explore the lengths to which this palette of single colors can be pushed by creating a gradient in a separate document. Use your software to see the range of a color by opening the Colors window (if it is not there, go to Windows > Colors). There is a range of tones in a color, ranging from light to dark, so you're not limited to a single tone per hue. When you're done creating a digital palette, you can eye drop from your tonal range to paint the details onto your dragon. For traditional users, you can do the same with a traditional palette.

Analogous Color 1

Analogous Color 2

Analogous Color 3

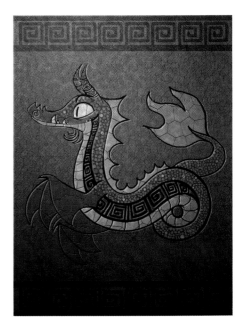

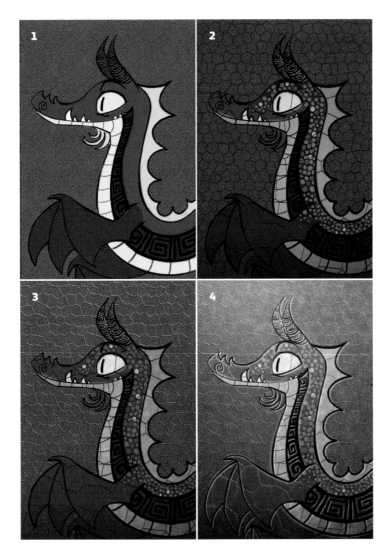

3 Lighting and Shading with Analogous Colors

Here, the images from 1 through 4 show you how to light and shade the painting using an analogous palette. Using your newfound dark and light tones from step 2, add detail and variety to your canvas. Add small details, such as specks of scales (using an analogous bright red color) down the back of the dragon. To create the effect of realistic cracks in the mural, I used the darker tones to shade the cracks, along with highlighting tones around the top edges of the cracks.

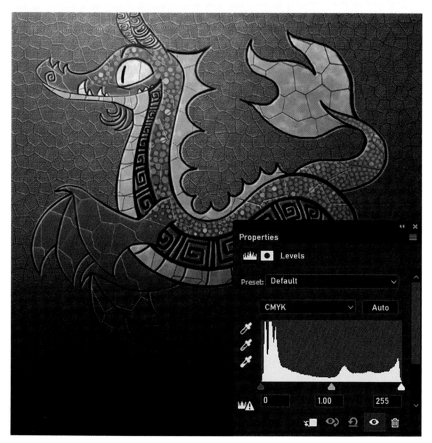

Using Levels

When the painting is finished, it can be useful to play with the Levels tool (available in Photoshop and similar programs). The Levels tool gives you three sliders: the shadows, the midtones and the highlights. Try altering them slightly to further balance your painting's colors and lights. For traditional artists, you can do the same by scanning your painted piece into a digital program and applying the level modifier to your painting.

Exercise 10:
Create Analogous Color Palettes

Start exploring color on your dragon, beginning with analogous palettes. Draw three busts of your dragon character and assign him three different analogous color variants.

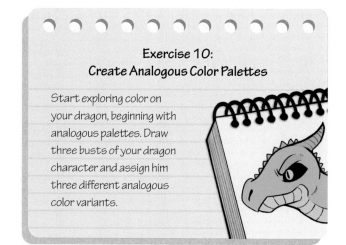

Complementary Colors

Complementary colors are colors that sit across from one another on the color wheel, such as red + green and orange + blue. When displayed together, the hues create a strong contrast. If you want to create artwork with a complementary color palette, limit yourself to two colors placed strategically.

Autumn Forest Against a Blue Sky

A crisp red-orange forest scene against a blue sky would be a balanced use of complementary colors.

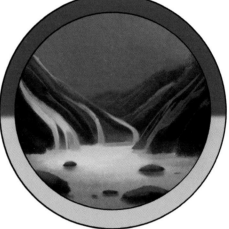

Magma Field

For a really stark example of a complementary scene, look up night photos of Icelandic or Hawaiian volcanoes or magma fields. Many photographs provide a good contrast between the red magma and cooler hues, like purple or blue.

Coloring Tip 3: The Mirror Technique

Mirroring your painting every 15 minutes or so while painting is a good way to ensure the piece looks correct from all angles. It's easy for our brains to adjust themselves to one angle and cause us to miss obvious mistakes. Almost all programs allow you to flip your canvas horizontally, which will give you a mirror view. In Photoshop, select from the menu *Image > Image Rotation > Flip Canvas Horizontally/Vertically*.

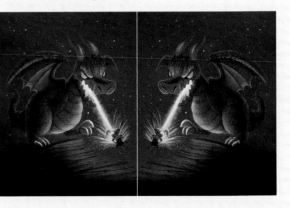

Alternate Way to Create a Palette

Some artists find that they can generate ideas for color palettes by blurring existing photographs until they are only three to five colors. You can also create a combination of palettes using several blurred images. The exact process of blurring an image will be different for every program, but if you are using Photoshop, do the following. After you have your desired image on a single layer: *Filter > Blur > Gaussian blur*. Bring the radius up as much as possible until the image is reduced to blotches of colors. Now you have a palette to eye drop from!

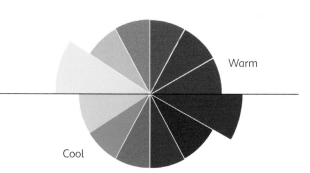

Choosing Warm and Cool Tones

Complementary colors always contain one warm tone and one cool tone. Warm and cool tones exist on opposite ends of the color wheel.

- Warm tones = red, orange, yellow
- Cool tones = purple, blue, green

Exercise 11:
Create Complementary Color Palettes

Explore even more color for your dragon using what you've learned about complementary colors. Draw three busts of your dragon character, but this time, draw them breathing fire that is complementary to the color of your dragon.

73

Complementary Colors on a Dragon

In the following example, you will see how a complementary palette works for a Western dragon breathing fire onto a knight. You will also learn how color can be used to create a *focal point*, as well as a few tricks on getting nice complementary color palettes.

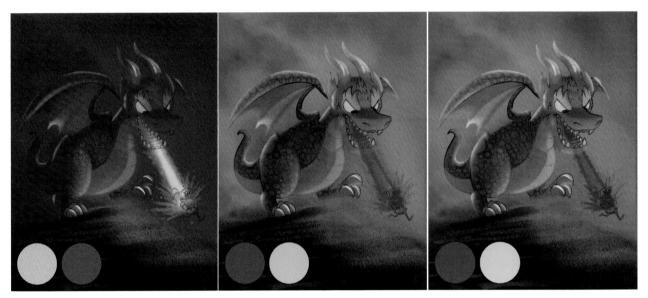

1 Create Complementary Color Variants

Come up with a few complementary color mixes for a Western dragon. Remember that we're limited to two opposite colors on the color wheel and no more. Create a few combinations to see what will work best, and keep in mind that you can limit how much of a color you would like to use. For instance, reserving one color for the dragon's fire.

I decided to use a purple and yellow combination, as this it makes the fire stand out.

2 Create Focal Points Using Color

A *focal point* is an area in a piece that catches the viewer's attention. As the artist, you need to define where the viewer should look. Although composition, shading and other techniques can dictate the viewer's attention, color can also be used to this effect. Thanks to the limited color palette in this piece, the dragon's fire directs the viewer's attention from the dragon to the knight—almost in a straight line!

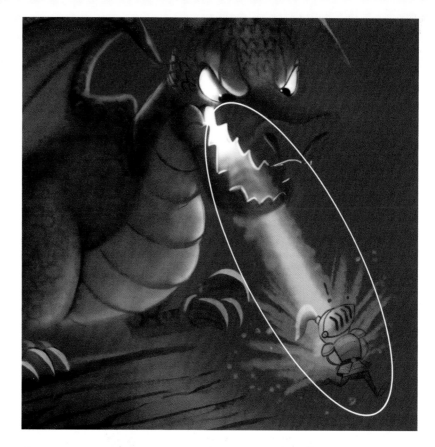

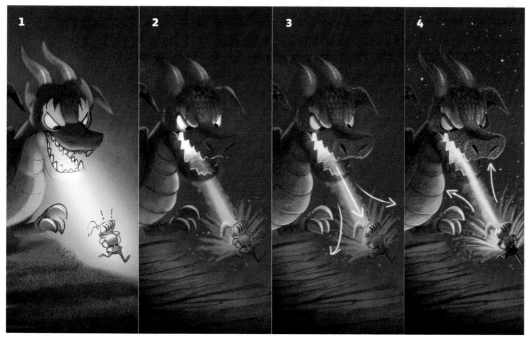

3 Use Surrounding Color Gradation

Here, the images 1 through 4 show you how to use the limited color palette to its best advantage. Though you still need to remain limited to two colors to keep the artwork's colors complementary, the intensity of the yellows will blend and form a gradation effect with the dragon's skin, the knight and the mountain. This will give you a greater range of color tones for the final piece.

Triadic Colors

Triadic colors involve three colors that are equally spaced from one another on the color wheel, like red, blue and yellow, or orange, purple and green. Colors in a triadic harmony are quite dominant, so you need to decide how to balance these powerful colors in your artwork without confusing the viewer.

Graphic Design and Pop Art

The triadic color palette works well for use in graphic design, logos and pop art because these types of illustration require stark contrasts to get the viewer's attention.

Stylized Art and Children's Illustrations

The vibrancy of triadic color palettes is well-suited to creating eye-catching stylized artwork.

Coloring Tip 4: Switching to Grayscale

Sometimes color can shelter flaws in the values of a painting. To avoid this, open the Hue/Saturation tool in Photoshop (or a similar program) and reduce the saturation of your painting to 0 to achieve a grayscale painting. Without the color to distract you, your eyes can better focus on what forms or details need improvement.

Triadic Colors on an Eastern Dragon

In the following example, we will see an Eastern dragon with a triadic color scheme. You will also learn how to blur or smudge details to bring focus to certain areas in a painting.

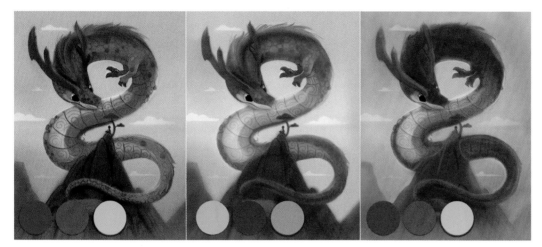

1 Select Triadic Color Variants

Select a few variations of the triadic color scheme that you think will work for your painting. Remember, this is a complicated color harmony. When creating variations, ensure that the dragon and its environment don't clash. You want to achieve a balanced look. It may be useful to keep the background light and the dragon dark to ensure it remains in focus despite the color limitations.

Triadic 1

Triadic 2

Triadic 3

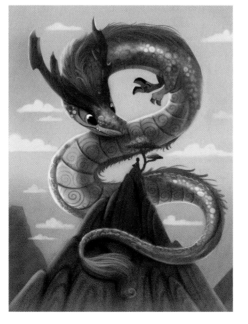

2 Explore Color Options

Explore the lights and darks that can be achieved with your chosen palette. Consider the end goal of your painting. Since this artwork involves volume and an environment, ensure that the color you pick provides balance. I went for the muted green, purple and red, along with a green dragon. I felt the green on the dragon would look more distinct and that purple would be better for the background. (Also, a green sky would look a little odd.)

3 Maintain Scene Harmony

Only use green on the dragon's body to make sure the dragon is the focal point. Keep the background muted by comparison, with lighter purples and light reds in the backdrop. Meanwhile, make the foreground (closest) mountain a darker purple and fade the farthest mountains into a lighter color. The dragon's shading should be determined by its environment, so since the purple hues are abundant in the background, shade it with a reddish purple.

Blurring the Background

Sometimes blurring background elements, like these mountains, can redirect the viewer's attention to the focal point (the dragon). After isolating the layer containing the mountain range, use the blur tool from the Filter menu on the tool bar to blur the selection. For traditional painters, you can carefully smudge background elements with your fingertips.

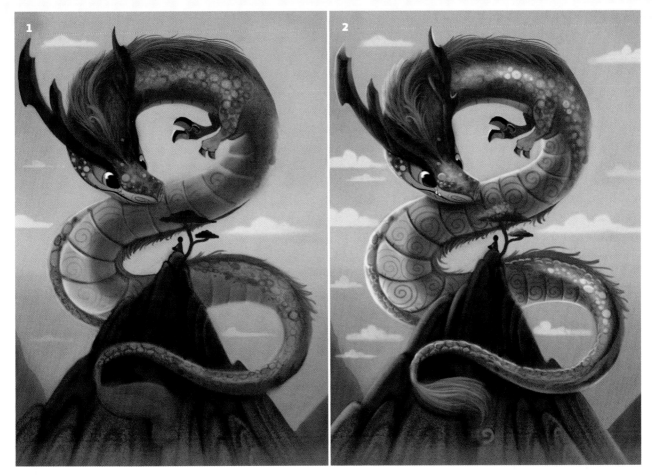

4 Recycle the Palette

The dragon was looking a little too green, so I recycled some of the red and purple hues into the scales. In addition, I used the lighter hues from the sky to give the scales some sheen. Both of these edits created further balance between the dragon and its environment.

Exercise 12:
Create with the Triadic Palette

Create a conceptual art piece for your dragon in a single scene using a triadic palette. Keep it simple for now; have the dragon fly through a night sky, above a mountain chain, over or in the ocean, etc.

Use Color to Tell the Story

Since paintings are rarely monochromatic, we can anticipate that we will use multiple colors. These secondary colors can be incidental, or you can choose specific colors to signify something in your painting. Imagine you're designing concept art for a dark canopy area. The dominating colors in this scene convey a threat, but you can also stream some yellow light through the canopy to convey a sense of hope—that there is a way out of the area. In this way, you can convey a subconscious story to your viewers with color alone.

Color Psychology

There is an underlying psychology to color. Colors evoke certain feelings and associations. Some of this is cultural. For instance, purple dye was expensive for much of human history and, even today, it's often attributed to royalty as a result. Other associations are instinctual. For instance, red draws our immediate attention because it's the color of blood. Thus, stop signs aren't randomly red. Though we should by no means allow color psychology to limit our artwork, it can be a useful tool when understood.

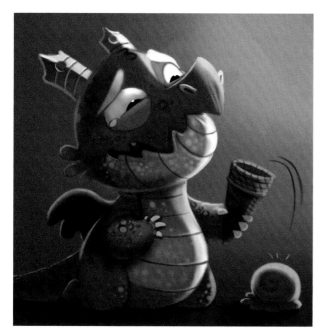

Color and Mood

Conveying emotion through artwork is a goal for many artists. The old adage "a picture is worth a thousand words" holds true. Films have been made completely absent of human voices or narration. Instead, they rely on color and imagery to convey a character's mental state. We all subconsciously relate color to emotions, and as artists, we can take advantage of this to create compelling storytelling in our work.

Common Color Associations

Yellow: Fun, joy, energy
Orange: Comfort, warmth, adventure
Red: Anger, danger, love
White: Purity, mystery, melancholy
Purple: Nobility, dreams, fantasy
Blue: Peace, honesty, quiet
Green: Hope, nature, harmony

Coloring Tip 5: The Color Balance Tool

The Color Balance tool is a function in Photoshop and similar digital programs. It allows you to alter the overall color of your artwork, though not perfectly. After using it, you should adjust the overall colors because the Color Balance tool will leave it looking a little monochromatic. However, this tool can be useful when creating quick color variations or for providing a head start into an edit. To access it, go to the Image menu, then select *Adjustments > Color Balance*.

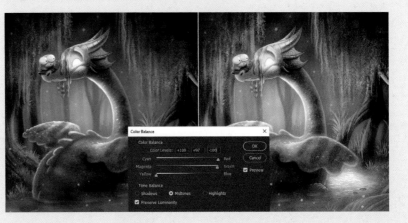

Coloring Tip 6: Color Thumbnailing for Traditional Artists

For traditional artists, you can consider scanning your sketch and experimenting with the colors before painting your piece. Since experimenting with color is so simple, you could also use a mouse instead of a drawing tablet should you not have one. If you prefer to stick with traditional mediums 100 percent of the way, consider creating quick color thumbnails of your composition using your medium of choice (paints, colored pencils, etc.). To do this:

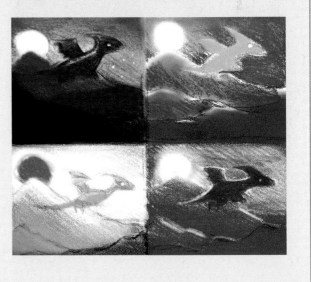

1. Take a blank sheet of paint-friendly paper and create at least four boxes of the same dimension that match the size of your composition.
2. Draw a *very* quick sketch of a composition into each of the four boxes. Just isolate the important elements of your painting.
3. Use your paints to create quick experiments for potential color schemes. This avoids the time-costly mistake of spending hours on a painting with a botched color palette.

Color Mood Scenarios for the Nessie Dragon

In the following examples, we will look at potential mood scenarios using the same painting. We'll see how these different color scenarios alter the color psychology of our paintings, despite there being no alteration to the painting's characters and setting. We can direct the storytelling of the piece to be a whimsical story about a frog that met the friendly Loch Ness dragon, or we can imply how doomed that frog is—just by using colors!

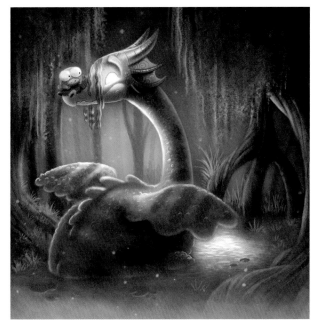

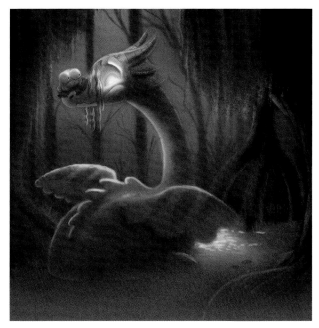

Mystery

One day, a frog waddled into a creepy swamp, only to be caught off-guard by a dragon. The frog can't tell if the dragon thinks of him as a friend or as lunch, so the color scheme should reflect this uncertainty.

- Blue: The blues contribute to a sense of isolation and cold, making you feel the dampness of the swamp.
- Green: The green hues prevent the blue from looking too serene and calming, giving it a more ominous look.
- Yellow: The yellows blend with a slight green to give a sickly, unsettling overlay to the piece.

Danger

Now imagine the frog is minding its own business when it suddenly hears a loud stomach growling from beneath him. The dragon's intentions are a little more evident here.

- Red: The brighter reds reflect a sense of immediate urgency for our friend the frog.
- Orange/yellow: The oranges and yellows cool the intensity of the scene. Red is an intense and distracting color, and it's best to use it sparingly (you want the viewer to appreciate the other details in the painting, too).
- Dark purples: The dark purple environment forms a barrier that seems to trap the frog in the piece.

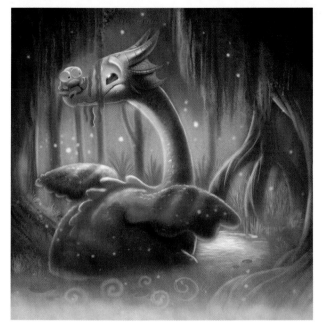

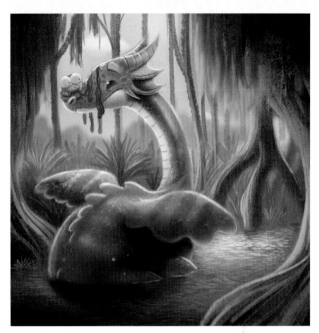

Fantasy

Imagine that, unbeknownst to our friend the frog, he has floated into a magical swamp and discovered its friendly guardian. Though the frog is startled, there shouldn't be anything in the color scheme to suggest immediate danger.

- Purple/blue: The purples combined with the blues provide a mystical serenity to the swamp and its surroundings. There are scarcely any blacks, with the darkest colors being in the purple trees.
- Pink/blue: A pinkish-blue mist settles on the base of the water, keeping the canvas free of darker hues.

Joy and Wonder

Now let's picture the frog enjoying a beautiful summer's day out in the swamp, playing hide and seek with his friend, the swamp dragon. Our swamp dragon quickly finds the frog, startling him in the process. Even startled, however, it would not be fitting to invoke colors that suggest immediate danger.

- Green/orange/yellow: The orange and yellow hues make the green a friendlier, more inviting color.
- Light blue: The light blues of the sky create a cheery atmosphere that provides light and clarity throughout the swamp. There are no colors that indicate hidden danger.

Color Studies

Creating color studies using films is a fun and useful exercise. Pick a film's scene, pause or screenshot it, and re-create it yourself. You'll find differences depending on the film's genre, year, or even with the individual directors. Some horror and thriller films, such as *The Ring* from 2002, have a continual blue-green hue to set the eerie mood. Other thrillers, like *The Shining* from 1980, have scenes that use blindingly bright whites against bright reds.

Exercise 13: Design with Mood

Create another simple piece of concept art of your dragon, this time with three different mood scenarios of the same scene: happiness, anger and mystery. If you're feeling bold, try designing his natural habitat— where exactly does your dragon and its kind live? If you're not ready to design a background yet, that's okay. Just keep it simple—clouds will do.

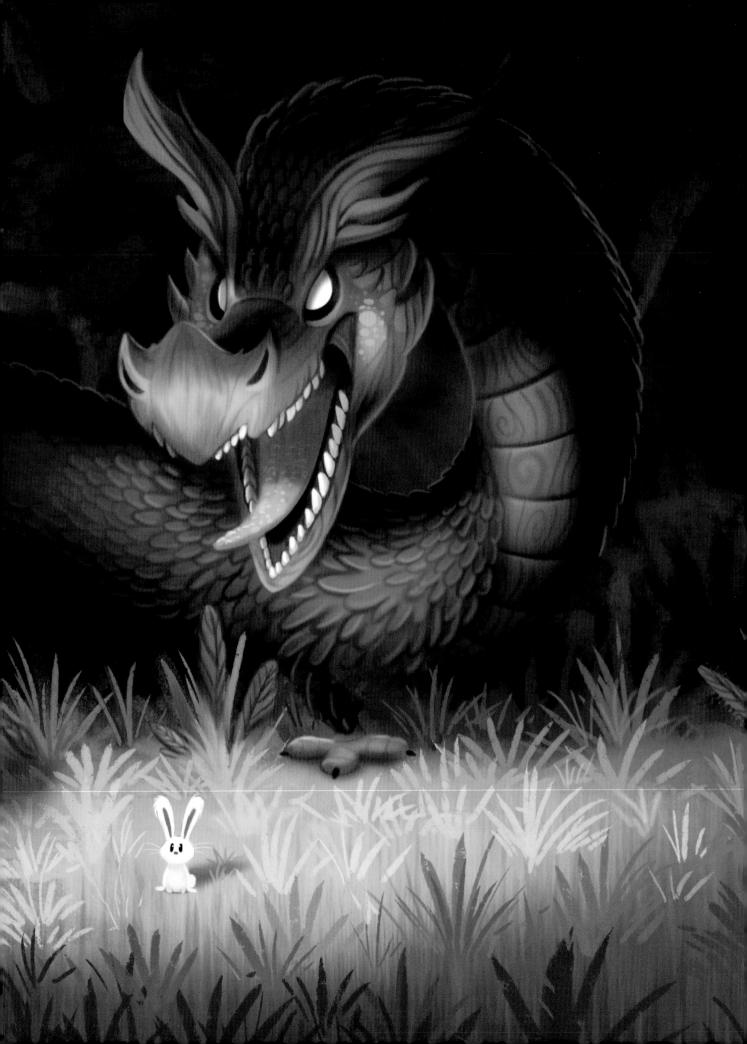

4 Lighting Dragons

Light is the most important element when it comes to any painting because nothing is unaffected by it. By learning how light works, we learn how shadows work as well—and that will give us all the more power to paint believable dragons.

In this chapter, you will learn how light and shadow work—from the very basics, like lighting up a sphere, to lighting up an entire dragon in its environment. You will learn first how to paint in grayscale and then move on to color. Additionally, you will learn about all sorts of lighting scenarios, ranging from the time of day to secondary light sources, like stars and fire.

Be sure to try the exercises in this chapter to practice lighting basic objects. It will help you immensely when it's time to finally apply lighting to your dragons.

Light and Shadow

Artwork that aims to create realism or stylized realism must use light to dictate the piece. Light determines the colors you can successfully use in a painting, along with the shadow placement. When starting an artwork, consider what light(s) will influence your scene and how that light will create the desired effect in your work. In the painting that opened this chapter, for example, the forest dragon requires an absence of light in certain areas to set the appropriate mood.

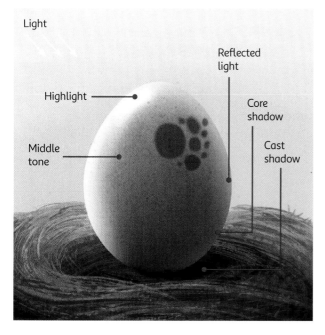

Light

Highlight

Middle tone

Reflected light

Core shadow

Cast shadow

Light and Shadow Terminology

- **Light:** Source of visibility.
- **Highlight:** A bright reflective area.
- **Reflected light:** Light not derived from the primary source of light.
- **Middle tone:** Transitional gradient of light to dark.
- **Core shadow:** The darkest part of the shadow.
- **Cast shadow:** A shadow cast by the subject.

Lighting Tip 1: The Dodge Tool

The dodge tool is available in Photoshop and similar digital programs. It allows you to brighten certain areas on a piece by increasing the specific exposure (amount of light) on a given area. Typically, after you're finished with your painting, this tool can be useful when applied in very limited amounts to a flattened image. It can be particularly useful for facial areas, especially eyes.

Lighting Scenarios

In the following examples, you will see how lighting can change depending on the time of day and how that influences your environments and subjects. The egg's lighting and shading are dependant on its surrounding environment (cave and nest) and the sky.

Daytime
A cloudless, sunny day will normally cast a nice mix of warm tones (from the sun) and cool tones (from the blue sky). In our setting, the egg is influenced by both.

Sunset
A strong sunset typically casts a darkened, but more intensely colored, warm hue to its surroundings. As such, the egg's shadow, as well as the mouth of the cave and the nest particles, should have more of a red influence .

Night
The night sky isn't entirely black, thanks to the moon and stars, so we can add hints of light purple to indicate light on the egg and cave entrance. The moon won't cast nearly as strong of an influence on the surrounding environment as the sun does. So while there's light, it should be much subtler.

Bad Weather
Bad weather can cover up the sun's rays and leave you with less light to work with. You can expect cooler lights as opposed to warm ones. You can also paint the egg's shadow and the cave with some blueish grays to reflect the cooler colors of the clouds.

Light Sources

A light source is defined as illumination in an artwork. Though we typically consider the sun or moon to be the light source in a piece, a painting that aims for realism or semi-realism should aim for more complexity. Light can bounce, affecting your subject and scene. Light that bounces on the ground can alter the color of a subject slightly. The highlight on a pair of eyes can be the difference between a character looking dull and lifeless or bright and lively. These small differences can make your art more realistic.

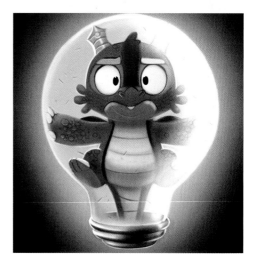

The following are some common types of light sources. These terms are frequently used in cinema to address lighting in scenes, but the same rules apply to artwork.

- **Key light**: Main light used in a scene (such as a flashlight in the dark).
- **Fill light**: The secondary light source.
- **Ambient light**: Light already present in a scene, such as light from the sky.
- **Backlight**: Lighting from behind.
- **Under light**: Lighting from beneath.

Lighting Tip 2: Plein Air Practice

For our traditional readers: Some of the most useful lighting practices come from observing how light plays out firsthand. All you need are some paints, pencils and a paint-friendly sketchbook. Find a simple subject, like a piece of fruit, and paint it in many different lighting scenarios. You'll notice that your subject won't retain the same colors or shadows in every scenario.

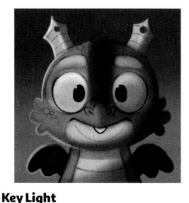

Key Light
The character is lit from a key light on the left, so the left side of the dragon is lit, while the right side is in shadow.

Backlight
In this example, the character is lit by a light from behind. The light traces over the edges of its contours as a result.

Under Light
Here the light is coming from an unknown source beneath the character, which creates a spooky appearance. This effect is commonly used in horror movies because it makes facial features appear uncanny to the viewer.

Stars, Ambient Light

In the absence of the sun, stars (and the moon) can provide an outdoor scene with ambient light at night. It casts a faint, cool light onto the Earth's surroundings.

Lightning, Backlight or Fill Light

The bright light from a lightning bolt can sometimes cast a bright backlight onto a character (if the lighting comes from behind) or a fill light to light their form.

Fire, A Versatile Light Source

Fire can be used for just about any lighting source, except, perhaps, for the sun itself (though it's also quite fiery!). Hold a candle beneath your chin and you have an under light. Hold it behind your form, and you have a backlight. Hold it next to your face, and you have a key light.

Bioluminescence

Bioluminescence refers to light created by a living organism, like a firefly, an angler fish's lure or even some mushroom species. This can create a key light for surrounding elements.

Lighting Tip 3: Overlay

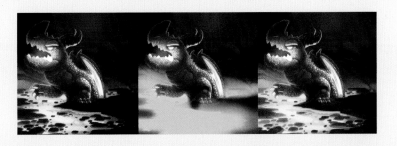

Overlays are a type of blend mode in Photoshop and similar programs. They allow you to add an additional lighting effect to your artwork. To use this mode, create a new layer and set the blend mode to Overlay. You can now either fill the entire layer with a color or airbrush areas to create additional lighting effects. This method is useful for slightly altering the color of a light source.

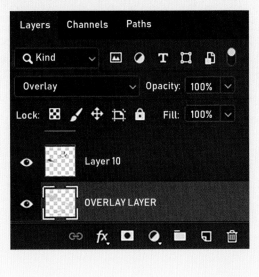

Lighting the Forest Dragon

In this demonstration, you will learn how to paint a camouflaging dragon in its environment. This exercise will focus on expanding the lighting principals that we mentioned earlier. If you're following along with the demo, don't concern yourself with the environment details, for now, if they're giving you trouble; we will cover environment painting later.

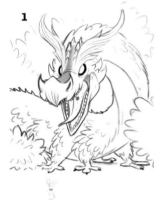

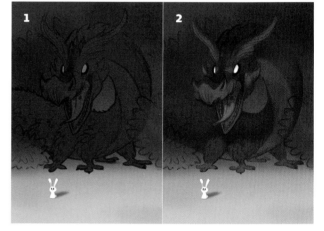

1 Place the Base Colors

Lay down the base colors of your drawing. Ideally, you want to use individual layers for each element: the dragon, bunny, bushes and overall environment. Create a new layer below the sketch and fill the desired area with color. Since this dragon is hunting the bunny, ensure that he blends well with the surrounding dark forest. He should have some color that will allow him to stand out amidst the background. In this piece, those areas are the greenish-brown skin and the white eyes. The bunny, who is standing in the bright clearing, will have lighter colors to help him stand out.

2 Create Form Shadows with Layer Masks

A quick way to add form shadows to your dragon is to lock the dragon's layer, duplicate the layer, fill the duplicate layer with a solid color (like dark blue or green) and then add a layer mask. This method allows you to use a white brush to erase the dark blue you've added and reveal the base layer. You can also use a black brush to re-create the dark blue shadow after you've erased it. To add a layer mask, simply click the vector mask button on the bottom bar of the layer menu (the square with the circle in it).

Layer mask tool

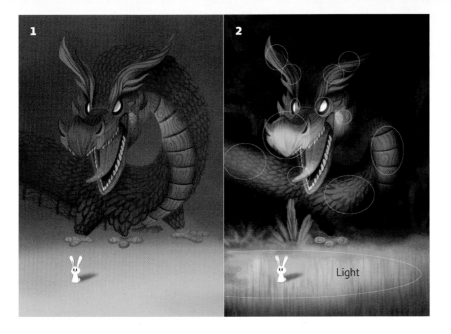

3 Add the Main Light

Consider how the light will reveal the dragon in the bush. You want the dragon to remain fairly camouflaged, with minimal light bouncing onto its details. The head is farther out of the bush than the rest of its body, so it will receive more light while the rest of the body blends into the darkness of the bush. Meanwhile, the bunny is fully exposed to the bright sunlight with only some mild shading resulting from the bush behind it. Use a large airbrush with a light opacity (or light pressure) with a soft color, like an off-yellow, to add the main light to the piece.

4 Add Additional Shadows

Cast shadows: The bunny will cast a strong shadow behind him. The dragon's lurching head also casts a shadow onto the forest floor.

Core shadows: The dragon and the bunny create subtle core shadows from the light they block from the ground.

To make these shadows, take a very dark green (to reflect the surrounding colors) and use a soft brush to paint the cast and core shadow areas.

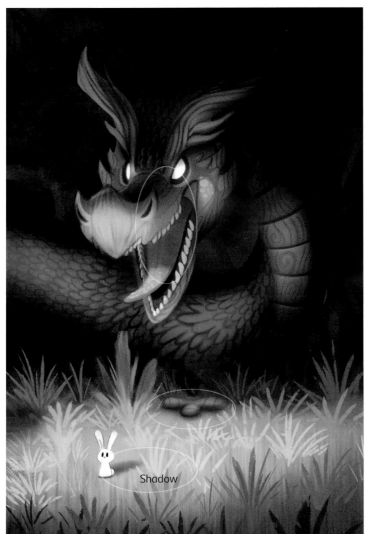

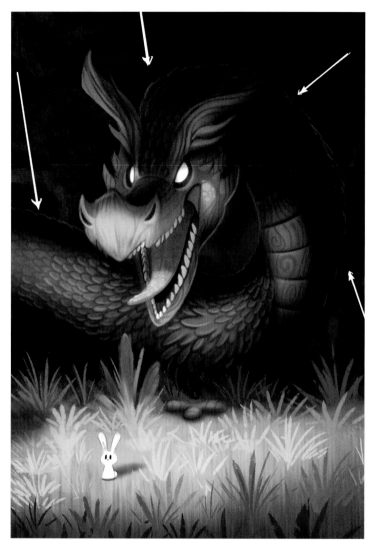

5 Add Additional Light

Reflected light: A slight green light is reflected from the forest floor
and flora onto our subjects. Very lightly brush this in with a light green
tint and a soft brush. The reflective light here is very minor, so be careful
not to overdo it.

Highlight: Add highlights to the slickness of the dragon's tongue, both
the bunny's and dragon's eyes and the glint of the dragon's teeth and
claws. To create highlights, use a fine brush with white paint and follow
along the edges that are exposed to the most light.

Middle tone: Given the tubular shape of the dragon, the middle
tones should provide a gradient effect for the body. Soften and blend the
gradient effect with an airbrush.

Lighting the Magma Dragon

Painting in grayscale is an art technique that limits your initial painting to a range of gray values. Since the lighting in this particular piece is complex, you're going to paint it in grayscale to ease the process, allowing you to focus on the different light sources rather than on balancing color. Another benefit to grayscale painting is that it allows you to backtrack the colorwork on a finished painting with ease. Some artists use this technique simply to set their lights and shadows rather than painting in all the grays. In this example, the magma dragon is painted in 70 percent grayscale and 30 percent color.

1 Create the Flats
Create a plain sketch of the dragon and lava setting (a loose sketch is fine). When finished, add flat (one color) grays to each important element: the dragon, magma field, mountains and sky. These grays should have different tones to differentiate them from one another. You may want to keep the layers for these separate so you can edit and add light more easily, but that's optional.

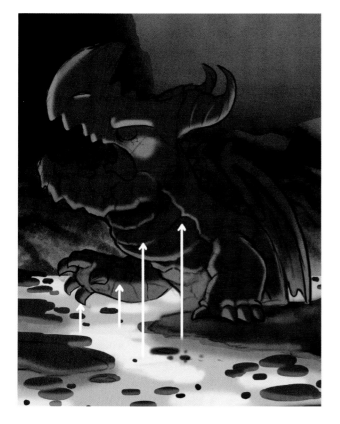

2 Add Major Light Sources
Decide what types of light sources you want and what direction(s) they're coming from. Create a new layer and name it Lighting Notes. Keep this layer above all the other layers. You will use it to add directional arrows and any other notes to your art piece, which you can toggle on and off while painting.

Light source 1, the magma field: The magma should be the strongest light source. The light coming from the magma is the brightest, and its light will bounce onto nearby subjects such as the dragon and the rocks.

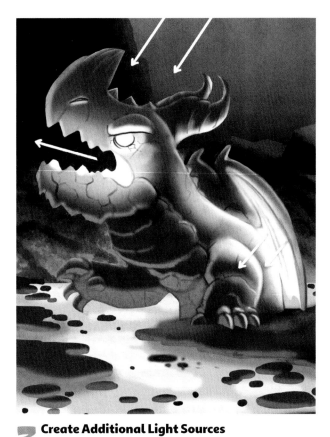

3 Create Additional Light Sources

Light source 2, the dragon: Being made of molten rock, the magma dragon emits the second strongest light sources in the piece from its mouth, eyes and wings. These light sources brighten the surrounding areas.

Light source 3, the sky (ambient light): Even if the night sky is muted in this piece, it will still contribute to the painting's environment, creating a better sense of realism. Add some faint light coming from the top edges of the dragon and the rocky environment, opposite the direction of the lava.

4 Detailing with Light and Shadow

Think of this stage as painting with light and shadow, as opposed to painting with color. Now that you've determined your light sources, it should be easy to add form and detail your work in accordance with them. You can detail as much or as little as you wish. In this example we're adding the smaller details like the rock cracks, textures and indentations. Use darks for areas that recede and lights near the light sources.

Exercise 15:
Explore Lighting

Use your dragon egg once more to create a series of four different lighting scenarios. Bonus points if you indicate the direction of the light(s).

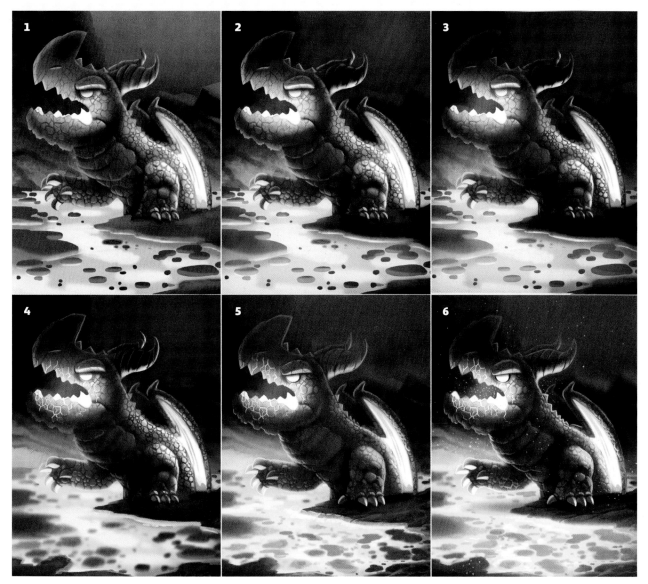

5 Convert Grayscale to Color

To add color to your grayscale painting while retaining the detail, create a new layer above your work and set that layer's blending mode to Overlay. Paint the Overlay layer with your desired colors. Additionally, if you want to intensify the colors, duplicate the Overlay layer to make it richer. From here, you're free to continue the work in color, if you desire, since your last priority should be getting the colors to work together. The numbers above demonstrate the sequential progress of the changes.

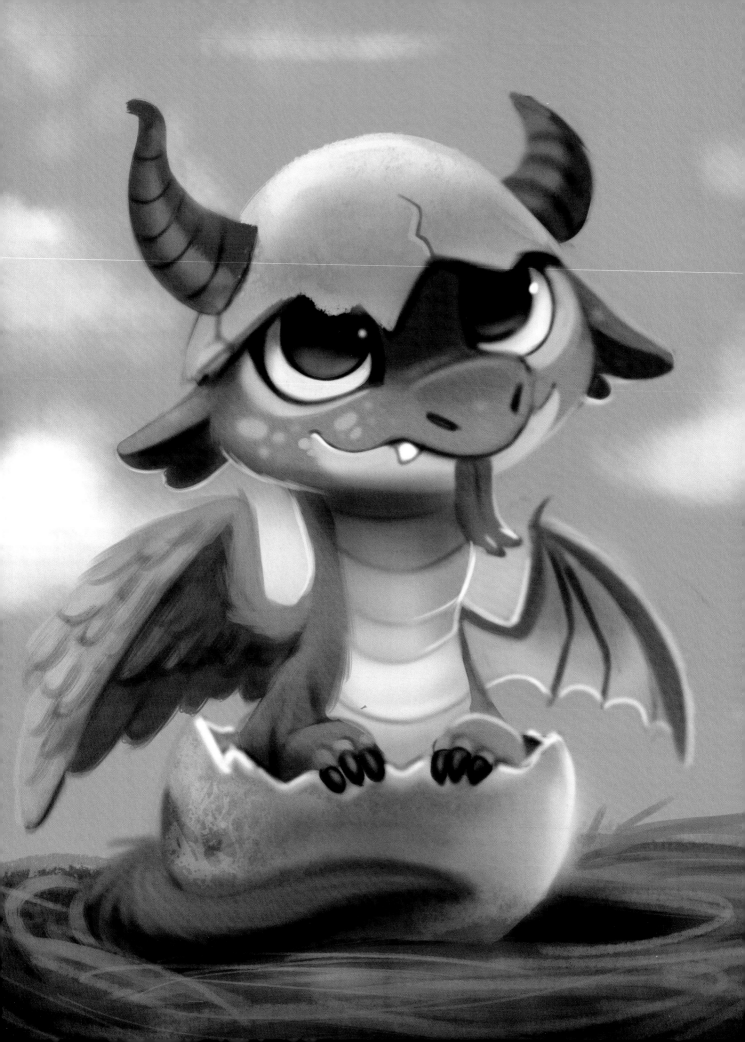

5 Texturing Dragons

Textures make the difference between the fluffy surface of a kitten and the prickly surface of a cactus plant. You wouldn't paint them similarly unless you want to draw a cactus cat. Many textures can be defined as smooth, soft or rough. Some have a consistent pattern, like a woven basket, while others are patternless, like rocks on a cliffside.

Without an understanding of different material surfaces, it's hard to paint anything realistic and convincing, dragons included. Though the content in this chapter may seem unrelated to dragon drawing at first, learning about textures will give you more freedom when it comes to painting your dragon illustrations. You'll get more freedom to design interesting and unique species of dragons, such as magma dragons, smoke dragons, crystal dragons and more.

Texture Eggs

Texture eggs can be used as a way to practice different textures by using a simple oval shape. The texture wraps around the egg surface and gives a 3D impression of how that particular texture would look. They're great when it comes to quickly testing a texture you're unfamiliar with or for general practice. In the following example, we will create a texture egg using a wooden surface.

Once you've practiced painting wood on a sphere-like surface, you can use this method for just about any texture.

1 Create a Basic Egg Shape
If you're using a digital program, lock the layer after this point.

2 Determine the Location of the Light Source
Here, the light source is in the top right, which will cast shadows onto the left side of your egg. Using a soft airbrush with a darker brown, lightly create a cast shadow beneath the egg and add some shading on its left edges.

3 Add Secondary Light
Despite the absence of any visible light sources, pretend there is a faint purple light coming from the left side. It's not as dominant as the one from the right, but nevertheless, airbrush some of its color as a highlight on the left side of the egg.

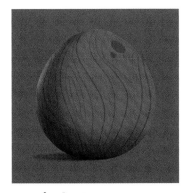

4 Begin the Texture
Try not to guess what a texture looks like. In this example, I looked up images of tree bark to get a better idea of how to draw bark lines.

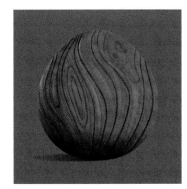

5 Deepen the Texture
Darken the cracks for the bark lines. With a light brush, make deeper lines and add a lighter brown to indicate more exposed areas. Add some of the purple highlight to a few exposed cracks on the left.

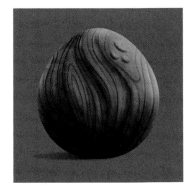

6 Finish
For finishing touches, darken the sphere to add more depth and add some very fine cracks, spots and moss details.

Scale Dragon

Scales are just about the most common texture you'll encounter when painting dragons. There is a surprising variety of scale textures in nature: a crocodile's rough and scaly body is not the same as a smooth snake. Western dragons tend to be depicted as having rough-looking scales similar to those of a crocodile. Meanwhile, Eastern dragons tend to have an elegant serpentine-like quality to their scales. This example involves a basic scaly dragon with soft scales. Read on to find out how to create this texture.

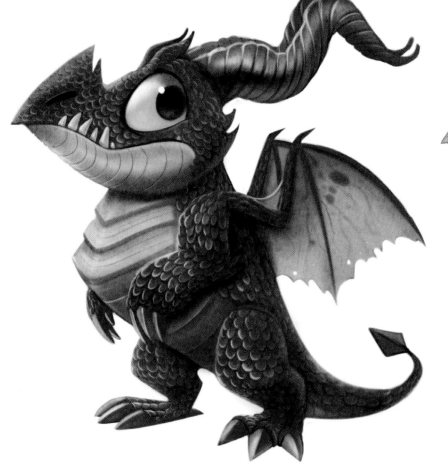

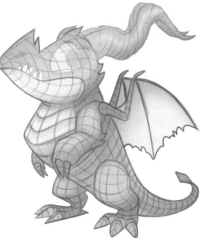

1 Add a 3D Grid

On a separate layer, overlay a blue 3D contour sketch over your dragon sketch to outline its volume. By creating a 3D grid over your dragon, you will have a better perspective of how the scales will flow over its body in the next steps. Be as detailed or loose with these grids as you see fit. They only serve as a mental guide.

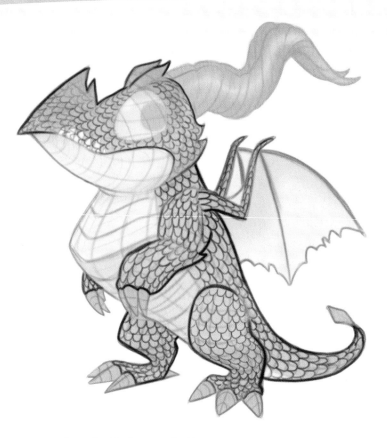

2 Create a Pattern for the Scales

Sort out the pattern of your scales before you commit to drawing them onto your dragon. In this example, the scales follow a pattern of interlocking scales, similar to that of a snake. Search online for *texture maps* of scaled animals. A texture map is a flattened-out texture, like an animal skin. You'll quickly see that scales are not random, even if they may sometimes look to be.

3 Lay the Scales on the Dragon

For digital artists, start by lowering the opacity of the blue lines. For traditional artists, erase the lines after you're done adding scales. Remember to "hug" the scales along the shape of the dragon, as though it were 3D.

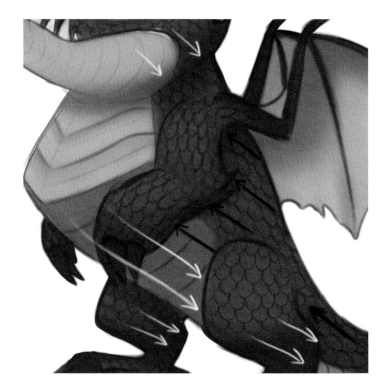

4 Add the Base Color and Shading

With the scales finished, you can move onto adding your base color and shading. Before shading the individual scales, determine how the light is hitting your character. The light is hitting this character from the top left, so the shadows on the scales should be stronger coming from the bottom right while the highlights on the scales should be stronger coming from the top left.

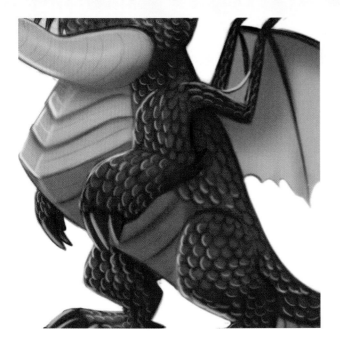

5 Shade Individual Scales

Now that you've sorted out the color directions, start shading the individual scales accordingly. Depending on how much time you're willing to spend polishing your dragon, you can either 1) choose to add the lighting detail to each individual scale to achieve a more realistic look, or 2) paint highlights and shadows for patches of scales to create the illusion of detail.

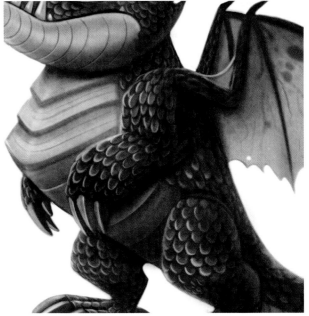

6 Add Details to Finish

When you're finished highlighting and shading, you can increase the realism of the scales by adding details such as markings, spots and scratches. Markings can be uniform or random. Again, it's helpful to look at texture maps of reptile skins to get a better idea of how they look in nature. Scratches and particle spots are almost always random. In this example, I used a gritty brush in Photoshop to give the impression of scale markings.

Exercise 16: Create Texture

Create three different texture eggs based on a smooth, soft and rough subject of your choosing. Use your sketchbook and any drawing materials you like, or you can work digitally.

Ice Dragon

Elemental dragons are no strangers to the fantasy genre, so learning how to paint ice and snow textures can better enable us to draw a snow dragon. In this example, we will create an Eastern dragon made out of ice and learn how to paint translucent materials.

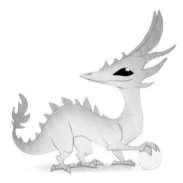

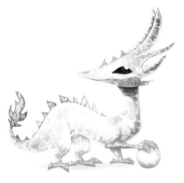

1 Create a Gradient Color

Ice is transparent, in general, so stay within the blue color spectrum for an ice look. In this drawing, I made a light faded blue base that gradates to a blue-ish purple in the tail, spikes and horns, and a greenish-blue in the feet and claws.

2 Add Shading

Decide how the shading for your character will work before delving into the ice texture. The light here is coming from directly above the dragon, so add shading to areas below the neck, knees and tail. You may need to repair the shading after toying around with ice texturing in the following step, but it's important to at least have a general idea of the light direction.

3 Add Crystal Texture

For the crystal texture, use a square brush to stamp out block-like patterns. Vary the sizes and color shades. If you are using Photoshop, you can apply a filter effect by accessing the top toolbar and going to *Filter > Pixelate > Crystallize*. This will make the block textures look more varied. Adding filters is completely optional and won't stop you from getting a similar end result.

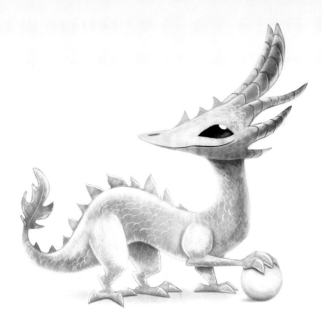

4 Refine

With the crystallized texture finished, use your program to blur the texture into the dragon's skin. If you do not have access to a blurring tool, smudging the colors or blending them into their surrounding textures will work just fine. Afterward, repair the lighting and shading. Ice tends to lighten around the edges, so lighten the edges of the dragon's body, particularly below its belly.

5 Add Snow

To add to the winter theme, cover the dragon in some snow. Using a blue-gray color, form clusters of snow patches along the dragon's body. As with scales, make sure the snow conforms to the body shape. Also, remember that snow falls from above, so it makes sense for the snow to accumulate on the dragon's back, horns, head and the upper parts of its limbs.

6 Finish

After completing the snow texture, apply the light direction to the snow clusters. The bottom of the patches should be darker while the top of the patches should be lighter. When you're done with the main snow patches, add some white speckles to indicate individual snowflakes.

Metal Dragon

With dragon art, we often come across knights wearing metal, but this time the dragon is wearing the armor for a change! Metal is a texture that artists come across often, particularly when painting dragons fighting warriors, for both armor and weapons.

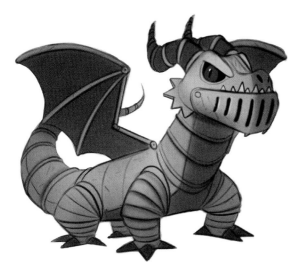

1 Add Grays

Add some varying gray tones to your sketch as a base. Generally, metal textures start off light and get darker as we go, so avoid using any colors that are too dark for now.

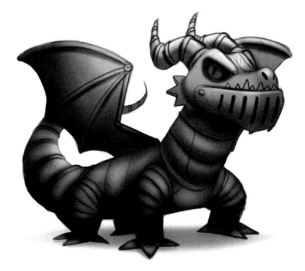

2 Create Shadows

Determine the light source (coming from the top right) and shade accordingly. Use a very dark gray to shade under the metal crevices.

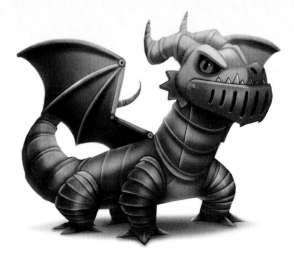

3 Create the Reflective Surface
Add light grays to indicate a reflective surface and highlight to the metal body. Line the ridges of the metal and along the dragon's body with the light gray highlight.

4 Add Realism
Using varying brushstrokes and different gray colors and textures, break the uniformity of the smooth grays. Add some brown rust to add an element of realism.

5 Show Wear and Tear
Use a white brush to create scratches and lines on the dragon's armor to show wear and tear. The scratches can look "scribbly" and vary in hue and width. Just make sure they're random.

6 Finish
Add shadows and highlights to the scratches to give them a more 3D effect. As a general rule, if the light source is coming from the top, place the highlight for a scratch below the scratch itself.

Fur Dragon

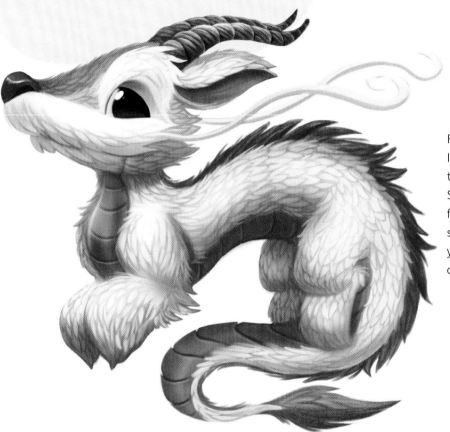

Fur is often used for Eastern dragons. It is also extremely varied. Look at all the different fur on dogs, for example. Some dogs are shaggy, others have fur so short and fine that it resembles skin. Look up all the different fur types you can find, even if this tutorial only covers one.

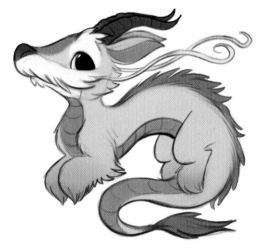

1 Start with a Base Drawing
You'll get an impression of the fur direction based on the 2D contours of your sketch. There isn't much to indicate the direction of the fur in the center of the dragon's body, however, so consider the ways in which it might grow.

2 Note Possible Fur Directions
In this example, the fur flows smoothly down from the neck region to the tail.

3 Start Fur Details

Following the fur path from step 2, draw interior fur details using a thinner brush to create the impression of thousands of individual strands of fur.

4 Refine Fur Details

Use a reddish-brown brush to draw clumps of fur along the natural flow of fur.

5 Indicate Multiple Fur Layers

With the clumped areas figured out, begin to paint over the clump lines to indicate multiple layers of fur. Use light colors for the exposed layers and darker colors for the bottom layers.

6 Finish

For the final polish, overlay bright color into the areas that are the most exposed to light, such as the top of the muzzle, the eyebrows, the nose and the horns, while darkening the shadow areas a little more. The fur now looks softer.

Feather Dragon

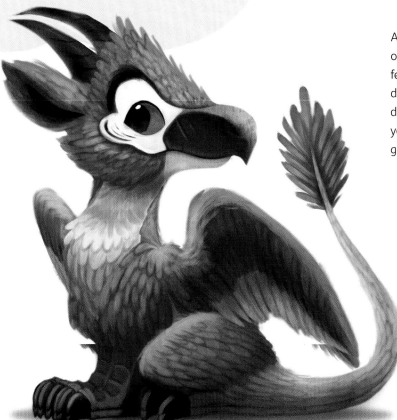

Although there aren't many myths or older depictions of dragons with feathers, many modern dragon artists draw such feathery features on their dragons. In the following example, you will learn how to paint feathers in general.

1 **Begin with a Flatly Colored Dragon**
Remove any signs of linework. Leave only the clean colored shapes of the character.

2 **Figure Out Feather Direction**
Draw the feather direction as you did with the fur tutorial. The feathers should have a directional flow; they aren't randomly strewn about.

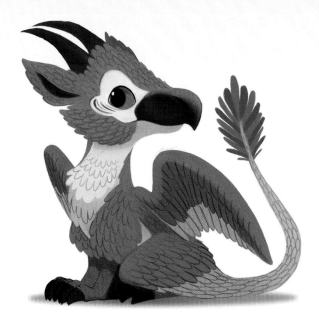

3 Add Feathers

Draw the feathers along the assigned directions chosen in step 2. Create the individual feather shapes to look like stretched, but rounded, ovals.

4 Refine Feathers

Begin filling the interiors of the feather lines with lighter blue and yellow feathers. Add some light shading beneath the feathers.

5 Begin Dimension and Texture

Begin forming more 3D shapes as you gradually add more shadow to the dragon in regions such as the wing interior, chest and neck. Lightly stroke a bit of a texture into the feathers to make them look more realistic.

6 Finish

For the final polish, fluff up the edges of the individual feathers with a bristle-like brush and lighter blue and yellow hues. The feathers now look a lot less dense and a lot more lightweight.

Nature Dragon

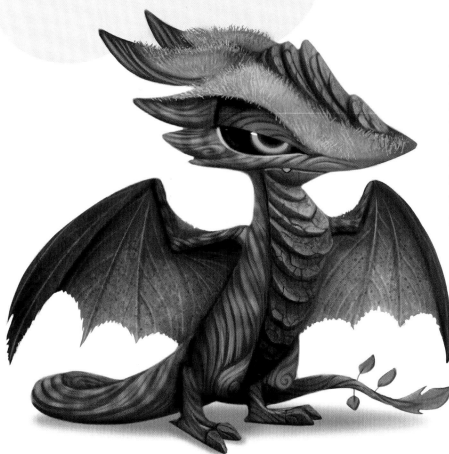

Many animals have natural camouflage based on their environments. Why should certain types of arboreal dragons be any different? This next texture walkthrough will explore what a nature-based dragon would look like. In the process, we will learn how to paint rocks and leaves, two textures that are quite common when painting backgrounds for dragons.

Wings, Leaf Texture

1 Begin with Base Colors
This dragon has a leaf texture on its wings. Fill in the base color and note that the typical dragon wing fingers will be replaced by leaf veins.

2 Draw the Veins
Draw light green veins to replace the black wing fingers. Like animal veins, the veins of a leaf work to distribute liquids, so their veins will branch out to "feed" the wing. Do the same here for the lines branching off the main vein.

3 Add Interest
Add interest with texture and shadowing to the faint elevations of the veins. Also, use the erase tool to add serrated edges to the tips of the wings.

Belly and Head Crest, Slate Texture

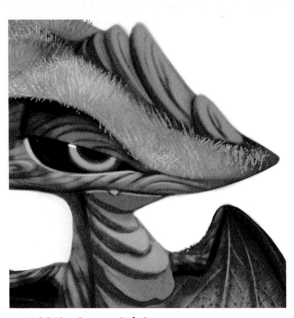

1 Begin Rock Texture
First, determine the shape you want. On this dragon, the rocks will look slate-like on the belly and the head crest.

2 Add Shadow and Light
Use a darker blue to create a thin layer on the slate rocks, and add shading to the of the top rocks, too.

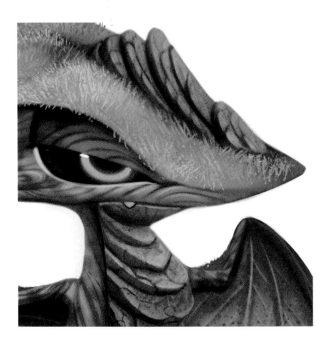

3 Add Wear to Finish
Rocks become worn over the centuries and show all sorts of cracks due to their exposure to the elements. Paint that wear into the rocks using a small, dark brush to make speck-like dents and cracks of varying sizes. Also, use a few different off-gray hues to break the uniformity of the rock color.

Sushi Dragon

Painting food may seem just about the most out-of-place subject this book could cover, but that's on purpose. Food has some of the most varied and strange textures to experiment with. If you can handle texturing food, you'll be better able to handle many of the more difficult types of textures. In the following example, we will texture a "sushi dragon."

Take some time to look up images of salmon sushi and rice. When drawing and polishing food textures, it's always helpful to have references handy to achieve better realism.

Chest, Salmon

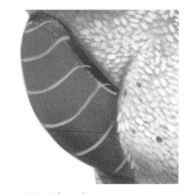

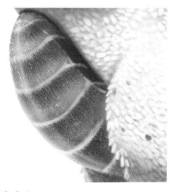

1 Begin the Salmon Slice
To paint a slice of salmon meat, remember that raw meat is a wet texture. A wet texture will catch more light because its surface is reflective. Define that light by using a small, hard white airbrush to indicate the cut edge of the salmon.

2 Add White Lines
Draw the visible white fat lines that raw salmon meat, in particular, tends to have. They should contrast against the orange quite visibly.

3 Finish
Add more highlights and details to the salmon. Break the uniformity of the white lines by lightly fraying them with a smudge tool (or your finger if you're painting traditionally). Looking at a reference photo of real salmon, you'll see that it tends to darken around the bottom of the white line, so add that as well. Keep nitpicking from your reference when painting food to make it accurate.

Head and Body, Rice

1 Begin Rice Texture
Rice texture involves a *lot* of details. For now, just get an idea of how the rice will look on the dragon by adding a layer of rice shapes. Create these by using a hard brush at full opacity and creating tiny, consistent strokes. This is only the first layer. We will add quite a few more layers to give the texture depth.

2 Complete Multiple Layers
A little cheating in the form of copying our own textures is very understandable when faced with so many individual details. To create a copied layer, right click the desired layer in Photoshop and select Duplicate Layer. Fill out the "skin" layers with multiple layers of rice until you barely see the bottom of the dragon's face. There are more than four different layers of rice in this image.

3 Finish
Tone down the rice noise from step 2 by softening and blending the surrounding rice. Do this by going over your finished work with an airbrush that uses a light rice color; soften some of the rice grains so that there are only a few sharp ones. This will look less jarring than a ton of sharply defined rice. Leave a few clumps of rice intact to maintain the illusion that there are a lot of individual grains of rice. Try to keep the defined rice away from the areas with shadow (like the neck region); you would see more detail in the areas exposed to light rather than the ones in shadow.

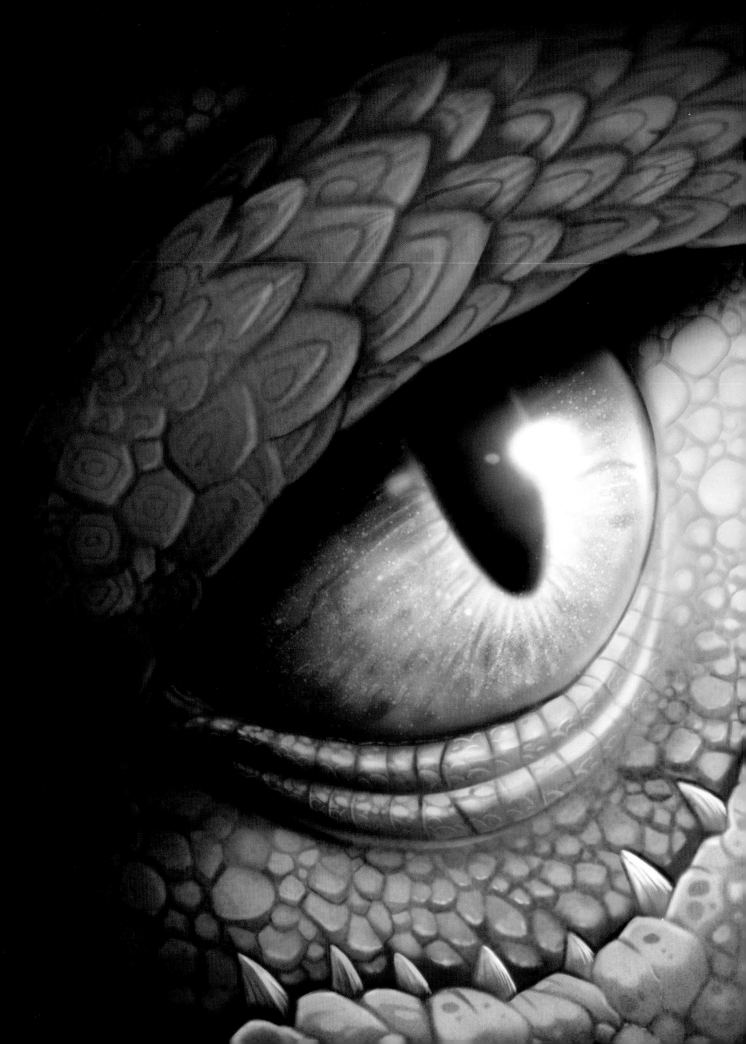

6 Detailing Dragons

This chapter concerns the finer details of a dragon's core features, such as eyes, mouths, horns, teeth and wings. This is different from the chapter on anatomy because our focus will be less on the underlying structure of features and more on getting those features to look accurate and appealing. Think of it as the cherry on top of your artwork.

Practice is essential to creating convincing dragon details. Since dragons are an amalgam of different animals, we should study how to paint and detail animals in order to help us with our dragon art. Here are a few ideas to get you started on making independent studies of animals:

1. Create quick paintings of animals based off of photographs. This will give you a better impression of details that you may not have been aware of.
2. Go to your local zoo, sketchbook in hand, and sketch the poses of the animals in their enclosures. You will end up with a reservoir of dragon poses.
3. Review scientific books on a variety of animal species to learn about their anatomies and behaviors. This may help generate ideas for your dragons.

Dragon Eyes

Dragons, being fictional creatures, come with a wide variety of eye shapes and types. You can give them human eyes, with a visible sclera region, as this helps characters emote and anthropomorphizes them. If you want something more animalistic, make them more snake or even catlike. This example is a mix of those two.

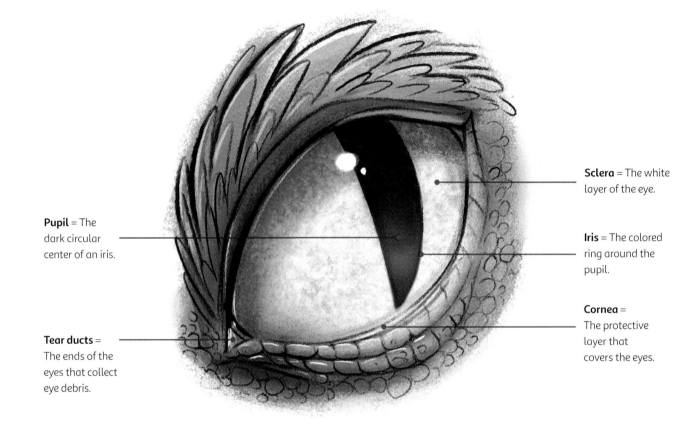

Pupil = The dark circular center of an iris.

Tear ducts = The ends of the eyes that collect eye debris.

Sclera = The white layer of the eye.

Iris = The colored ring around the pupil.

Cornea = The protective layer that covers the eyes.

Eye Drawing 101
Eyes are some of the most important details in a dragon drawing. They are one of the areas that we're naturally drawn to first in a painting. As such, it's important to keep them looking realistic if we want to achieve realism. So it's good to educate ourselves on what makes up the eye.

1 Determine the Eye Shape

Here the eye shape is oval, like a human's, and tapers in the corners to the duct. Unless you intend to give your dragon bulging cartoon-esque eyeballs, make sure the eye isn't perfectly round and that it's overlapped by the top and bottom eyelids. Make more or less eyelid overlap the eye according to your preference and what you're trying to achieve with your design.

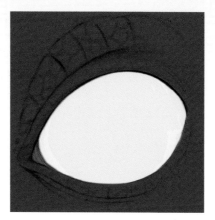

2 Color the Surrounding Skin

Use a dark bluish-gray for the skin around the eye, and make the sclera a yellowish off-white. Use a pinker color for the tear duct.

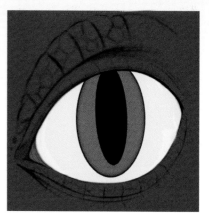

3 Add a Pupil and an Iris

Draw a black slit with an amber iris around it to give the eye a catlike feel. Alternately, make the iris brown to humanize the eye.

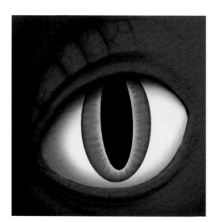

4 Continue Refining

Paint a lighter color coming from the center of the pupil and darkening as it moves outward. Also darken the edges of the iris to give it more depth.

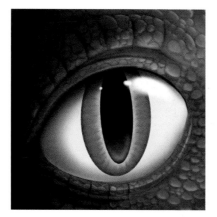

5 Add Light and Shading

Cast a light onto the cornea from the top left (where the light source is located) using an airbrush. Shade around the sclera using a darker yellow.

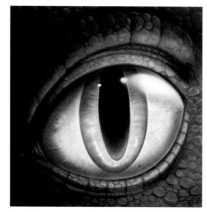

6 Finish

To finish, add texture to the eyes. Using the thinnest brush you can manage, select a dark yellow or red and lightly add small veins around the eyeball. Make sure the marks are faint. For a touch more realism, add more color variance and a few age spots with a light airbrush and a few brown hues.

Dragon Teeth

Once again, since dragons are fictional, we can base dragon teeth on of a variety of animals. Dragon teeth could look *homodont*, where the teeth are the same shape (like alligators and piranhas), or *heterodont*, where the teeth have a specific outline (like incisors and premolars in mammals).

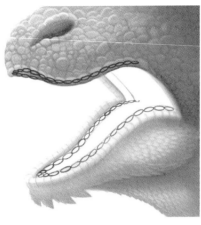

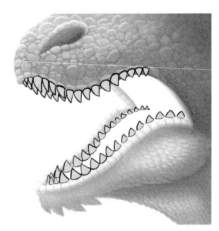

1 Indicate Teeth
Draw red circles to indicate where the teeth should stick out in the dragon's mouth. Keep the same number of teeth on each side of the mouth so that it doesn't look off.

2 Draw the Teeth Shapes
This dragon is a homodont, so the tooth shape is the same. No need for incisors and molars. You can begin adding a pale off-white color for the teeth. Remember that dragons don't have access to toothpaste, so it's unlikely that their teeth would be pearly white. Even the best human teeth aren't perfectly white, so make them a yellow hue, even if it's faint.

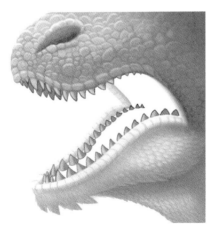

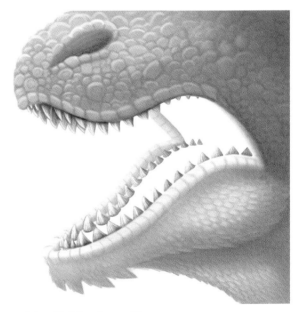

3 Refine the Teeth
Conform the tooth shape to the mouth by erasing the exposed areas outside of the mouth and fitting them into the jaw. Add shading to the teeth with an understanding that the shading should follow the cone-like volume of the tooth. Generally, unless the dragon is breathing fire, the teeth should be darkest on the corners and bottoms, as there is no light source in the mouth. The tooth should be brightest at its center, facing the outside of the mouth.

4 Add Individual Details
Finally, add individual tooth details, like wear lines, and additional light to make them stand out in the mouth and look less uniform.

Painting Mouths

Dragon mouths are important because they're often seen snarling and blowing fire, so be sure you learn how to render them. They can be mammalian, reptilian, or both. This example is mammalian.

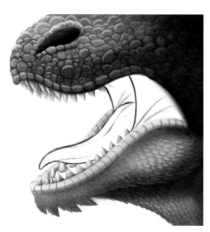

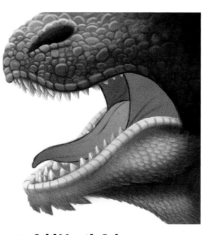

Tongue Forking

You can draw a hybrid between a mammalian tongue and a reptilian tongue by forking it into two halves before following the tutorial. Just add light airbrushing to both tips of the tongue.

1 Flesh Out the Tongue
The tongue looks vaguely human, but with a sharper tip at the end to give it a more reptilian appearance. Draw a line in the middle of the tongue to divide its volume in two so it's more realistic. Also, add skin flaps to the sides of the jaw.

2 Add Mouth Colors
Using a reddish tone, go from lighter on the base to darker at the tip of the tongue. Make the interiors of the skin flaps darker.

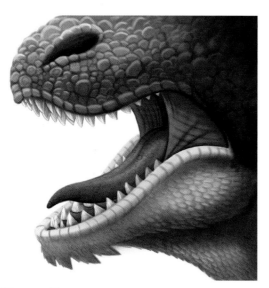

3 Add Tongue Textures
Add patches of circles and folds to the skin flaps on the mouth. Think of it like rubber that allows the dragon's mouth to stretcher wider. With that in mind, the skin should bunch up a little when the mouth is not fully extended.

4 Add Detail
Create highlights, and remember it's a wet surface. Add detail to the tongue along with some hanging saliva by using a white airbrush along the middle of the tongue and contouring around some of the tongue's bumps.

Dragon Horns

When you paint horns, consider that horns are extensions of the skull and are poking out of the skin. It's important that they don't look slapped on.

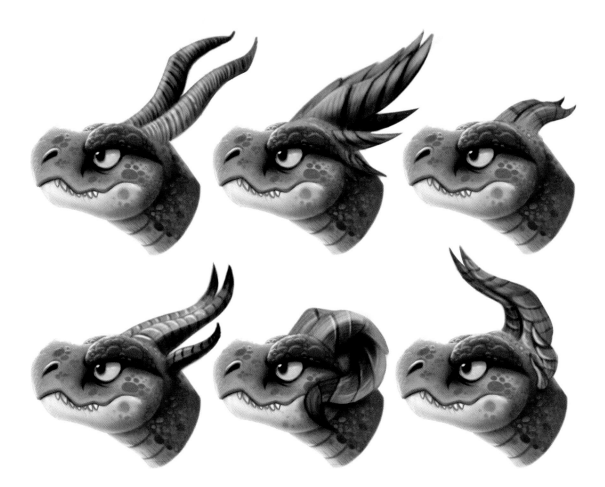

Horn Variations

When you're considering how to draw the horns, remember why they look the way they do. Sometimes they're evolved for defense, like with a rhinoceros. Sometimes they're ornamental to display fitness to females or to compete with other males. Thinking this way will help you come up with clever horn designs rather than randomly drawing shapes.

1 Draw the Exterior Horn Shapes

Don't worry about the interior shape right now. Mirror the horns so they're similar (unless you don't want them to be).

2 Indicate Ridges

Consider how the horns are sectioned. Are they entirely smooth? Or do they have curly ridges, like these? Indicate ridges with dark shadows.

3 Apply a Base Color

This will help you better see that the lighter part is pushing outward, closer to the viewer, while the darker bits are farther away.

4 Add Defining Strokes

Add scratchier, uneven strokes to differentiate the horns. If you had identical horn details before, use different strokes at this stage to ensure they don't look mirrored.

5 Add More Wear Lines

Add more horizontal wear lines. Be careful not to mirror your painting details so that the lines look more organic.

6 Finish

Even out the line textures and blend them slightly into the horn. Use highlights to embed them and add spots and more lighting and shading to make them look less tacked on and more natural.

Dragon Pointy Bits

Unlike horns, back spikes are usually not part of the skeleton itself. Even a stegosaurus' plates aren't directly attached to the spine. Dragons can also be adorned with *scutes*, which are bony external plates that look like spikes. Sometimes they have gill-like spikes with membrane tissue. In all cases, be conscious about how the spikes are working off the body.

1 Figure Out the 3D Shape

For a snakelike texture, start by figuring out the 3D shape of the tail using a blue grid. Then, using an HB pencil, add multiple rows of scales that wrap around the shape. If you are using traditional tools, make sure your drawn scales are evident enough that your coloring won't wipe them out.

Spike Variations

Much like horns, the sharp bits on a dragon, such as the spikes, tail and claws, could be used as a means for defense, killing prey or decoration. Consider this when designing your dragon's features.

2 Add Base Color and Begin Shading

After the scale pattern is finished, erase the 3D grid and add a base color to the tail. Shade the bottom of the individual scales to make them pop. Since these scales are smooth, like a snake's, the shadows shouldn't be too harsh.

Add some grooves and wear lines to the spike plates to better define them along the tail.

3 Improve the Spike Texture

Add light to the grooves and more definition to the ridges. Once the tail is fully painted, polish the scales by adding white highlights along the edges of the scales where the light would hit them.

4 Add Another 3D Overlay

Use colored pencil and include more intersections so you can figure out how to lay down the scute spikes (to make the skin more crocodilian and spiky).

5 Draw the Scute Scales

Follow the path of the tail and add some bubbly scales along the bottom. Remember, they need to conform to the 3D shape. Try to vary the shape and boldness of the scales to make the tail look more natural.

6 Add Color and Texture

Include the scutes along the tail to make the skin appear rougher, like alligator skin. Add highlights and sheen to the scute scales to highlight the sharpness of the scute's ridge. Try to lightly highlight along the outermost area of the shape. Don't add too much, as the area is quite rough rather than smooth.

Dragon Wings

Dragon wings are some of the most important details for dragons. You need to understand how the skin works under light. In the following examples, we will delve into how to draw realistic wings, but we will also cover how subsurface scattering causes wings to look the way they do.

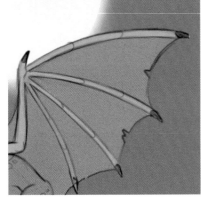

1 Lay Out the Wings

Since we're quite close to the sun in this image, start off with a medium orange. If we were farther away from the sun, it could be a darker orange.

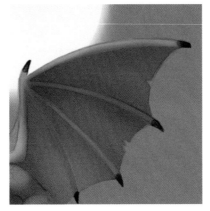

2 Add Shading

You're in plain view of the sun, so the shading should be strongest around the points where the wing fingers meet the membrane, and also where the membrane is the thickest.

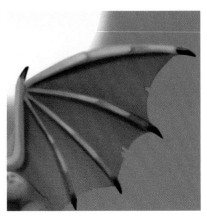

3 Begin the Wing Finger Details

The top digits are closer to the sun, so they should be lighter.

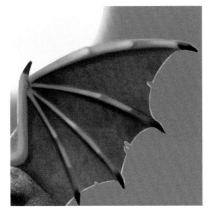

4 Add Messy Texture

If your aim is something more realistic, avoid making the dragon wings look too clean or perfect. They should be weatherworn and organic. You can achieve this by taking darker and lighter colors of the current wing color and lightly spotting brush strokes around the wings to create imperfections. You can also add highlights around the edges of the membranes.

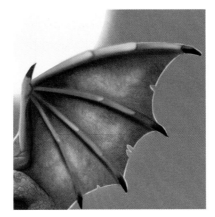

5 Adjust the Lighting

Increase the light for the thinner areas that are most exposed to the sun. The middle of the wings is now a much lighter orange. If you're using Photoshop, use the Burn Tool to achieve this look.

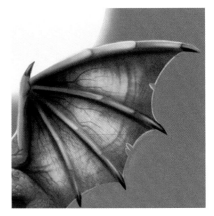

6 Finish

Add some folds of excess skin and the impression of veins. Very lightly crosshatch some nicks and scratches onto the membrane.

Painting Veins

Dragon wings, like any body part, need to be supplied with blood in order to function. Since wing membrane is very thin and prone to tearing, it has very few veins. (This reduces bleeding.)

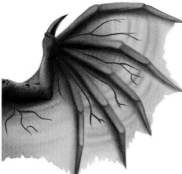
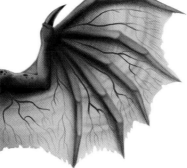
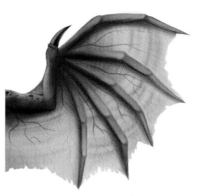

1 Draw the Main Veins

The main veins will be the thickest. Think like a vein; where would you position yourself to distribute as much blood as possible across the membrane?

2 Add Smaller Branches

Smaller veins branch off the main veins and taper off in opacity to the edges of the wings, which is the area with the least amount of tissue.

3 Finish

Blend the veins into the texture of the wing, either by lowering the opacity or by lightly blending them in. The topmost veins, which contain the most blood, should remain a little darker, while the bottom ones should lighten.

Subsurface Scattering

Subsurface scattering, also known as SSS, refers to how light passes through an object or surface. The more translucent an object or surface is, the more SSS you will see. As a general rule, if something is thinner, like wing tissue or your earlobes, then it's easier for light to pass through it visibly. SSS could reveal details, such as veins or even bone structures, that were not noticeable under normal lighting conditions.

Look at this dragon egg. In direct sunlight, you would be able to make out the impression of the embryo (you could do the same with a chicken egg in real life). The more developed the baby, the thicker the membrane inside becomes, so it becomes less translucent.

Conversely, since rock is not translucent, it would be virtually impossible to get any SSS passing through a stone egg. However, the edges of the rock will show a strong highlight.

Dragon Fire

Fire is a visible combustion of oxygen and a fuel source, so a realistic fire should look as gaseous and non-solid as possible. It should have a strong base flame, while the tail of the flames should taper off. Note that painting the tail of a flame with a hard brush makes it look too solid.

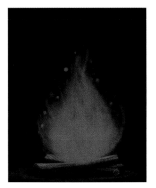

1 Start with a Pile of Firewood

Draw a teardrop flame shape sitting atop the sticks using a soft airbrush.

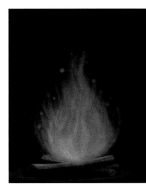

2 Add Continually Lighter Layers

Add a lighter red at the base of the flame and gradually layer lighter colors atop the flame. It should be brighter at the base, and that brightness should bleed off as it reaches the tail.

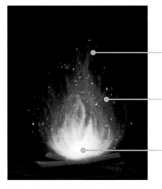

Tail = The tip of the flame.

Halo = The glow of the flame.

Base = The starting point of the flame.

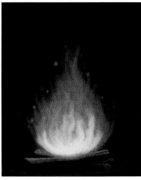

3 Create More Contrast

Gradually add more light to the base of the flame, creating a contrast between the faded red of the tail and the bright yellow base.

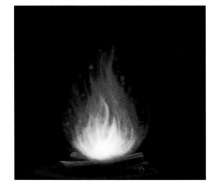

4 Color the Base

Add an almost-white color to the base to reinforce that it's the strongest point of the flame.

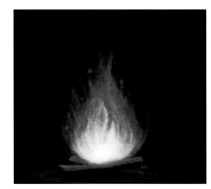

5 Add Texture

To give the impression of texture in the flame, use a light yellow brush to place some embers in the middle of the fire.

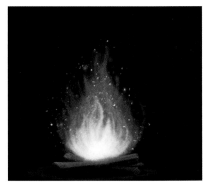

6 Finish

Speckle multiple embers bleeding off of the flame's exterior. Make them varying sizes, opacities and widths for more realism.

Breathing Fire

When learning how to paint dragon breath, focus more on the speed and intensity of the flame. There are many different ways to paint fire breath, but as a general rule, it should not look like a laser beam. We want more of a jagged, organic look, and we will achieve that by creating a natural-looking flame shape, then coloring and lighting it accordingly.

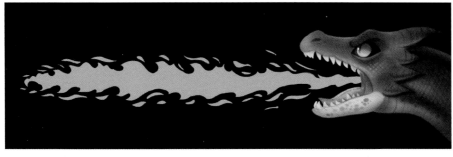

1 Draw a Long Teardrop Shape

Draw a long oval teardrop where the dragon is shooting fire. If you're using Photoshop, erase or crop along the edges of the teardrop to make it look organic with no straight edges. If you're using traditional materials, draw a teardrop shape lightly on paper and pencil in the organic edges along the shape.

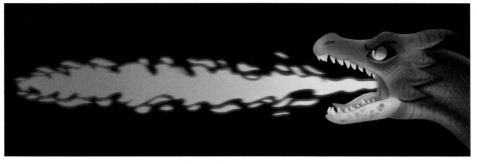

2 Adjust Lights

Consider that the base of the flame is at the dragon's mouth, where the fire is starting. This should be the brightest part; the rest forms a gradient from orange to red toward the tail.

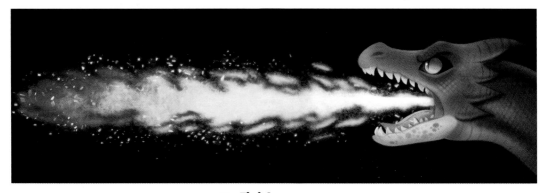

3 Finish

Smudge the flames along the edges to give them more motion. Add some ember specks and texture to the flame.

127

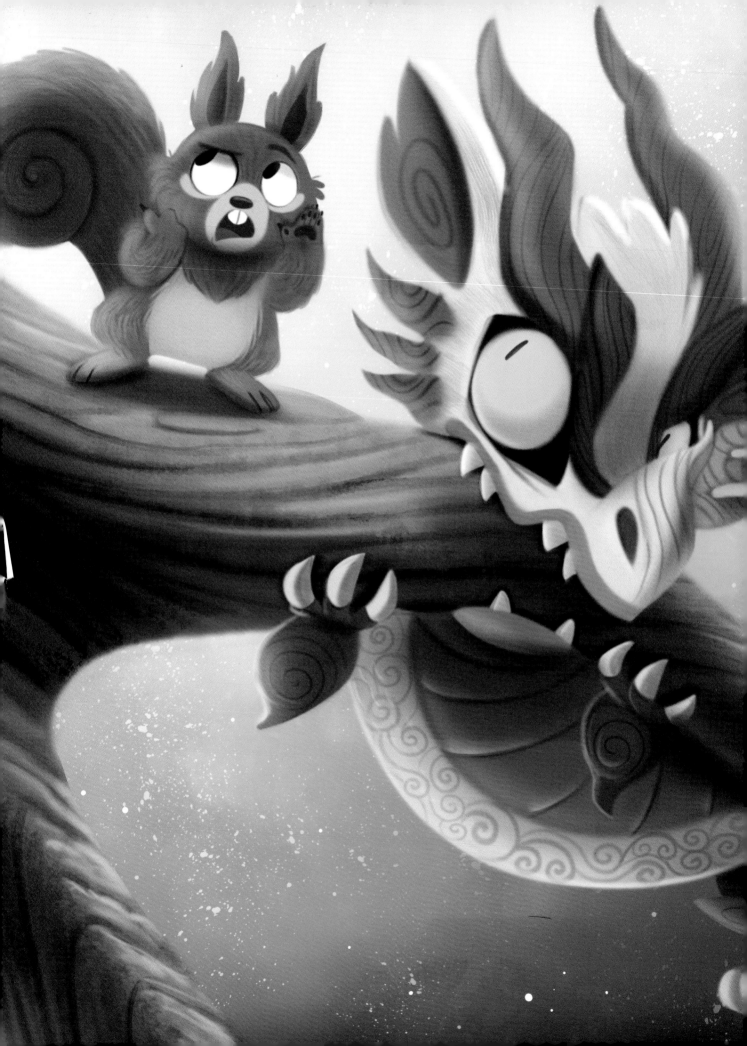

7 Drawing Dragons: Start to Finish

You've made it to the final assignment. To reinforce all you've learned, your last task will involve designing and painting a dragon from start to finish. This stage will emulate what it's like to design a dragon for a project, whether it's animation, illustration, toy design, etc. Keep in mind that your focus will be to move the concept along with your drawings. Avoid going with your first drafts without exploring other options. Projects often have multiple artists working on them, so the more options there are, the easier it is for a team to select a design. I will include commentary on the evolution of the designs. I encourage you to note your own commentary on your sketches as you work through this stage.

You will begin with a detailed dragon prompt for your characters that will give you a project to work with. Let's say that, hypothetically, this is a character for an animated short film. We will also be touching on all the lessons so far: character exploration, poses, expressions, coloring and environments. You may follow the tutorial 100 percent to achieve the same results, or you can try your hand at your own interpretation of the prompt (recommended).

Step 1: Exploring Dragon Designs

The Prompt: The Legendary Níðhöggr

Hailing from Northern Germanic mythology, Yggdrasil was an enormous cosmic ash tree that held all the Nine Worlds. At the roots of the tree, a wyrm named Níðhöggr gnaws on its roots. A great eagle, of whom Níðhöggr is not fond, sits at the top of Yggdrasil. The squirrel, Ratatoskr, carries messages and gossip between the eagle and Níðhöggr, which infuriates both of them.

From the prompt, you can gather that Níðhöggr is a touchy creature, easily upset by the squirrel's gossip. Gnawing at the roots of Yggdrasil could be interpreted as terrifying (it's the tree that supposedly holds our world, after all!) or a pathetic, vain effort. So you have two roads to explore your character through: serious or goofy. Experiment with both in the sketch exploration phase.

Be prepared to make multiple sketches that will follow the dragon through initial character concept to final artwork. Ideally, you want to keep the early sketches (anything that won't need to be polished with color) loose. You don't want to get caught up in a design and become attached to it. This is all about trying your designs by fire! In my own process, I've used Photoshop to complete the following steps, but I encourage you to use traditional means, as well, particularly in the sketch portions, as drawing loose freehand sketches is good practice for general sketching.

Sketch 1
A little too much like an Asiatic dragon and not enough like a Western one. Also, it's too intimidating. The wolf-like mane could be an interesting and unique touch, however.

Sketch 2
More of a Western dragon than the first sketch and a little less intimidating. The lack of legs could be interesting. A little too fluffy, though.

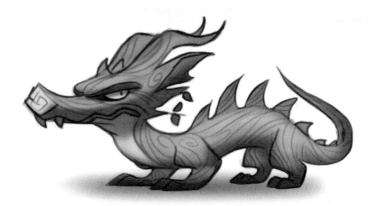

Sketch 3

What if we incorporated tree-like elements into Níðhöggr's design, similar to the camouflage of a stick-insect? However, he may blend in a little too well with the tree if he's entirely made out of bark like this sketch.

Sketch 4

A bit too neurotic-looking and fragile, but otherwise getting more interesting. Instead of bark, I tried some other tree-like elements, such pine needles for wings, pinecone tail tip and a tree at the tip of its nose. Fun!

Sketch 5

Here I mixed sketches 3 and 4 together. I constrained the bark elements from number 3 to the eyebrows, back spikes and legs. I used the muzzle and a toned-down version of the neurotic look from number 4. I think we have our dragon!

Step 2: Character Exploration

Now that we've settled on a semi-neurotic looking Níðhöggr, we can further explore what kind of character he is through sketches. Being neurotic isn't enough to give him personality. When you sketch him, consider how this character would interact with the world around him. How does he greet the squirrel? Does he relish juicy gossip about his eagle rival? How would he react if the eagle called him a smelly worm?

These expression sketches will explore different facets of his personality and would be useful to have if the end product were an animation. We want to flesh out the character's emotional range in the beginning with the sketches, as that could impact its design.

Note 1

He's an expressive and dramatic dragon. He'll laugh hysterically if he gets any good dirt on the eagle.

Note 2

He'll also easily snap and snarl if he's returned with any insults. Particularly if they involve him resembling an earthworm.

Note 3

He's not exactly evil . . . just very goal oriented.

 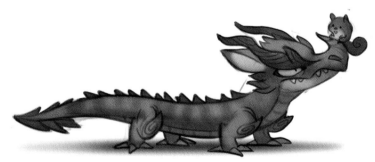

Note 4

He may be an enormous dragon (cosmically speaking), but he can barely coil himself around the roots of Yggdrasil.

Note 5

He's on pretty good terms with Ratatoskr and won't harm the squirrel.

Step 3: Color Drafting

So we have the design and personality figured out. Now, on to color. Consider that the Níðhöggr will need to pop out from the tree, otherwise he will look bland and uninteresting. Although the basic design is finished, the final color can nudge his appearance to look more majestic, more animalistic or more intimidating. Let's try all of these approaches to find out which works!

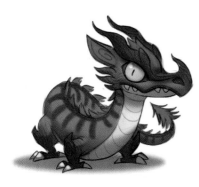

Draft 1
Old Norse rune stones tend to have dark red inscriptions embedded in them, so some dark red markings can give a similar motif. He is a little too bark-colored in this example, however.

Draft 2
Here he looks like some sort of jungle dragon. Kind of neat, but ultimately not what we're aiming for since he's supposed to live in the cosmos.

Draft 3
Dark and mysterious with some hyena spots. This could be a fun design direction, though he may be a little too sinister looking for his goofy personality. Also, the dark colors might make him hard to distinguish in a space setting.

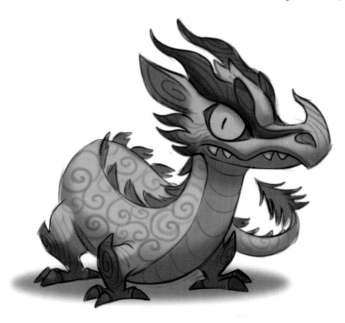

Draft 4
Still going for the sinister approach, but more on the purple side to make him less intense. Also, the markings are now mock runes, which works well. Nice color palette, but he still might have a hard time popping out against a space setting.

Draft 5
Much more regal (and snooty). Seems to be a lot more in line with the personality we derived from our sketch phase. The pine elements in the tail, spikes and ears are more evident against white scales. Let's go with it.

Step 4: Develop Details & Textures

With your dragon design and color finished, you can either move straight into the concept art stage or create a final character render and call it a day—or do both! If you decide to follow through with this assignment, you will have a better idea of your character's details and textures before you start your concept art. More development artwork is always a bonus.

1 Create a Clean Line Drawing
Keep it simple. You can use one of the character design poses or create a new pose. Showcase as much of the dragon's features as possible. Avoid angles that could hide anything important.

If you're working digitally, put the line drawing is on its own layer.

2 Add Color
Apply the colors from the color drafting stage. If you're using a digital medium, add a layer under the line layer to retain the render and color.

3 Get Rid of the Lines
Either delete the line layer or paint directly over it. I painted over the existing lines. If your drawing still doesn't feel 3D enough, try adding some shading.

If you're using a digital medium, lock the layer for your render as you shade the character. Remember, locking a layer means that you can draw within it.

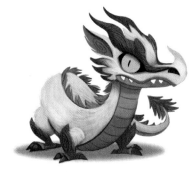

4 Add Texture
There are four primary textures for Níðhöggr: fur, scales, pine and bark. His fur flows in a scruffy pattern down the length of his body to the tip of his tail. Draw individual pine lines for the scales and tail tip, along with root lines for the bark horns and limbs, and lines for his belly scales.

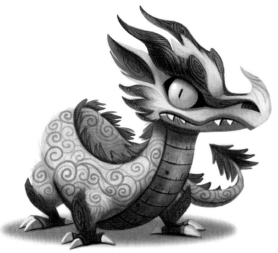

5 Add More Shading and Depth to the Textures
For his fur, add an ornamental fur texture using a light gray airbrush. For the bark lines, add varying hues of gray-brown to emboss the texture. For the belly scales, add cracks, spots and a reflective surface to convey wear and tear (think of it like armor: it should show some wear after use).

Step 5: Thumbnail the Scene

Before spending a lot of time on a final illustration, it's wise to play with potential compositions of the scene. You can change many things while you work, but reworking a composition mid painting often yields bad results. Take 15–30 minutes to create a few loose thumbnail sketches and choose from there.

The goal for this final concept art, based on the prompt and the current character direction, is to portray Níðhöggr comically gnawing the root of Yggdrasil while Ratatoskr shares a few choice words from the eagle.

Note 1

Níðhöggr hangs pathetically from the root with the squirrel informant. The dragon looks funny hanging from the tree like that! But Níðhöggr is supposed to gnaw on the roots. This root looks too branch-like. Additionally, the side view angle is too flat and uninteresting, and the squirrel is pretty boring.

Note 2

Now Níðhöggr is coiling himself around Yggdrasil's roots with the squirrel pointing upward to the eagle. The storytelling is better with these visuals: the dragon is looking at the squirrel who is pointing upwards, which leads the eye and makes it more entertaining. However, this is still a little flat, and Níðhöggr looks very large compared to the root, which takes away from the comedy we're aiming for.

Note 3

This time, Níðhöggr is farther up the root and can barely get his mouth around it. The dragon looks goofier now, which is good! However, the vertical angle of the root makes it look like the base of a small tree—not good.

Note 4

Improving from the mistakes of our last thumbnail, now he is gnawing the root (horizontally) while the tree is in plain view. Though this is better than the others, the composition is noisy. The focal point is shared between the tree and our characters.

Note 5

This last thumbnail gives us a different angle than the last attempts, with the dragon now looking dwarfed by the tree. This focuses more on the character's expressions and personality, which is important since this concept artwork is comedic and character oriented. Let's run this version through some color tests and start rendering!

Step 6: Scene Color Options

Color options let us foresee mistakes before we commit to them in color. When creating them, try to explore as many color variations as you can. Don't play it safe by using only slightly different colors than your initial color sketch. Don't dawdle on the thumbnails, and try to keep each individual color edit brief (unless you have a very complex background).

Option 1

What if the bottom of Yggdrasil was a fiery pit while the top was beaming with heavenly lights and hues? In this test, we paint bright halo lights beaming onto Níðhöggr from above. The contrast is interesting, but it gives off too much of an epic feel.

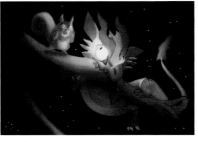

Option 2

What if Yggdrasil was set against a plain starry sky? Since this would rob us of any light sources, we compensate by giving Níðhöggr glowing yellow eyes. While fun, he comes across as too creepy, and the black background is bland.

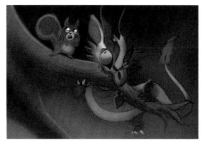

Option 3

What if the bottom of the tree was a foggy and mysterious place? Here we have a nice a contrast with the purple colors against the focal point of Níðhöggr's yellow eyes. However, this makes the tree look like any old root you'd find in a forest. Yggdrasil is no ordinary tree!

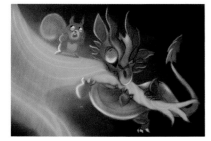

Option 4

What if the tree glowed a bright mysterious color? We could have some great blue bounce lights to play with, but it feels like our environment is taking priority away from the comic scene we're trying to portray. If you're aiming for something more serious, this kind of color palette would work quite well.

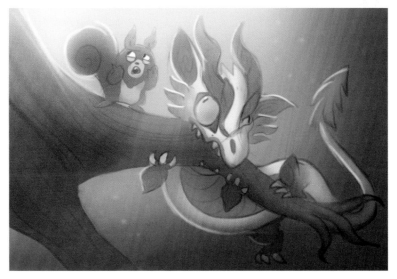

Option 5

Finally, I set the characters and scene in a starry nebula. The background is now appropriate to the setting. Yggdrasil is clearly set in space and doesn't look like a random tree in the woods. There's a good gradient of warm colors on the top left flowing into cool colors on the bottom right, which makes the scene visually appealing. Let's take it to render!

Step 7: Paint the Background

Concept art can sometimes focus only on characters or environments, but in some instances it can involve both. The background here plays as much of a storytelling role as the characters. Yggdrasil is said to be a cosmic tree that connects the Nine Worlds, so we will aim for a space-like setting to keep it faithful to the myth.

1 Paint a Gradient

I used yellow-green on the top left and a cobalt blue on the bottom right. Using an airbrush, create a gradient between the two colors to create depth.

2 Overlay Colors and Add Stars

Research images of nebulas to get a better idea of the colors you can pull off. You can make this effect really interesting by overlaying several colors to make the nebula pop. Remember: Stars aren't a bunch of uniform white dots. They can be random or clustered, with some brighter than others.

3 Create the Roots of Yggdrasil

Use a separate layer from the background. This is a detailed object in the painting that characters will interact with. Anything significant like this should have it's own layer, otherwise you risk having to repair your background continually.

4 Add Bark Details

Trees often have gnarled details and crevices. Vary the widths of the crevices and avoid uniform colors or lines. You can also add texture to demonstrate the depth of the tree's roots. The more variety you add, the more fun the tree will look.

5 Finish

The roots were looking too faded and out of place in space. With the root layer still locked, add the influence of the two gradient colors (yellow-green for the top and cobalt blue for the bottom). Using an airbrush, add darker colors to the areas that are the least exposed to the light sources. Now the background is prepped for the characters!

Step 8: Character Rendering & Detail

This step focuses on getting Níðhöggr and Ratatoskr to mesh with the painted environment. The starry background and the branch were painted before the two characters because it's the dominant palette. If you want to have characters feel like they're not out of place, they must comply with the world, not the world with them. Remember that color is in the eye of the beholder. For instance, the color of your T-shirt is entirely dependant on lighting; it won't appear the same color in every situation.

1 Place the Line Drawing

Place your line drawing from step 5 into the scene. There's no need for extremely clean lines because you will paint over them, but try to keep your drawing clean. If you haven't already, lower the opacity of your original thumbnail sketch and trace over your underlying artwork. Feel free to make changes to the dragon (that don't involve changing the design or scene setup). If you feel like something is off, like the eye placement or limb position, it's better to change that now rather than later.

2 Paint Níðhöggr and Ratatoskr

Paint the characters using their respective color palettes. Don't worry about how out of place they may look initially. It's a gradual process. Pick a shade from the background to use as a light shading for this stage. In this example, I used an off-purple for the squirrel and dragon. It won't be the final shading, but it's always good to leave some visual directions for when you reach the end stage.

3 Begin Refining

Determine the dominant color, which in this case is a purple hue. Níðhöggr's skin should form a gradient from the off-white to a faded purple. Render important details like the face and eyes at this middle stage, as well. Faces are important, so we want to figure them out as soon as possible during the rendering process. Here we'll use the purple hue to shade the corner of the eye so it looks like it's bulging (this character has very bulgy eyes).

4 Begin Smaller Details

Add details to Níðhöggr's skin, horn, ear and arm. Add more detail to Ratatoskr's fur. The light is coming from above, so his fur should be lighter on the top tip of his tail.

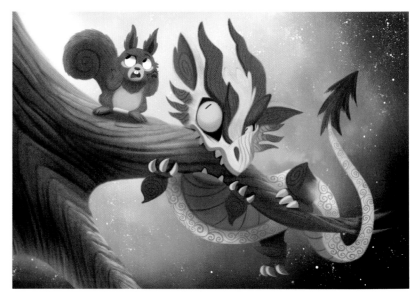

5 Finish

Blend the characters into the setting by bringing in the less dominant light source (yellow). This light is coming from the top left, so it shouldn't influence Níðhöggr as much as Ratatoskr. Using a soft airbrush, gently dab some yellow into the left side of the dragon while airbrushing the squirrel more generously. Now our characters feel like they're a part of the world!

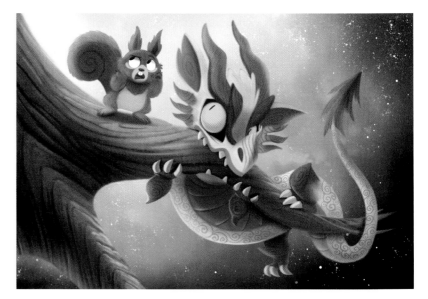

Congratulations!

You've made it to the end of the book! I hope the reading and tutorials have helped to guide you on your quest to drawing and designing dragons. Keep in mind that while art books can be a useful tool for an artist, nothing can compare with the sheer determination to keep practicing as much and as often as you can. "Practice makes perfect" may sound like an overused platitude, but I can't overstate how pivotal it is for your overall improvement as an artist. You have to make "bad drawings" to learn from your mistakes. And that leads us to our final assignment. . . .

Exercise 17:
Draw Daily

For your seventeenth and final exercise, make a daily commitment to drawing in a sketchbook. It can be as little as a five minute doodle or as devoted as a full page of sketches. Don't limit yourself to dragons, either. Draw from life and your imagination. Dragons, cats, dogs, horses, people, cars, your morning pancakes— keep your sketchbook at your side at all times. Inspiration can pop out of anywhere.

Keep up the practice and your dragons will be looking fantastic in no time!

Wishing you all the best on your drawing adventure,

-Quill

Index

IMPACT Books

An imprint of Penguin Random House LLC

penguinrandomhouse.com

Printed in the United States of America

1 3 5 7 9 10 8 6 4 2

ISBN 978-1-4403-5426-7

Edited by Mona Clough
Designed by Clare Finney
Project managed by Noel Rivera

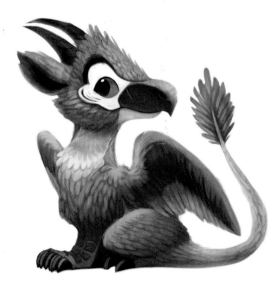

Dedication

To fellow artist and author Tom Bancroft for being an important source of inspiration. His book *Creating Characters with Personality* left an enormous impact on me when I was a kid and helped me to shape my own career in character design.

Acknowledgments

The making of this book was most certainly not a one-person job. I want to give a special thanks to the book's editors, Noel Rivera and Mona Clough, who did stellar layout and editing work for the book. To Clare Finney, for her design direction on the book's cover and her work on the interior. To Pamela Wissman, who made this book possible, and to IMPACT Books for publishing it.

I also want to give thanks to my dear mother who helped me with countless second opinions on the book's content and revisions.

And, lastly, a very special thanks to the people who've helped my work get the attention it has: to those who've supported me on Patreon and to those who view and share my work on social media. This book would have been impossible without you guys.

About the Author

Piper Thibodeau is a freelance character designer and former DreamWorks TV character designer hailing from Quebec, Canada. She has been creating a painting a day since 2012 for her "Daily Painting" series, which can be followed on her social media platforms.

Website: www.piperthibodeau.com
Twitter: @Piper_Thibodeau
Instagram: @piperdraws
Facebook: www.facebook.com/CryptidCreations
DeviantART: www.deviantart.com/cryptid-creations

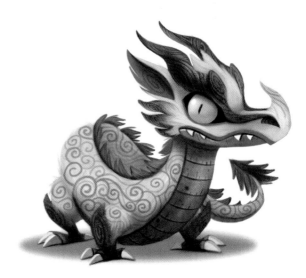